IMAGES
*of America*

# LAOTIANS IN THE SAN FRANCISCO BAY AREA

**ON THE COVER:** After delivering the Sunday newspaper, these Laotian teens explore their new city in 1983. From left to right are Sarathy Janetvilay, Chanthavy Sackdavong, Somaack Sirivath, Kongchanh Moeya, Loy Soumpholphakdy, and Thae Sirivath. (Courtesy of Boutsaba Janetvilay.)

IMAGES
*of America*

# LAOTIANS IN THE SAN FRANCISCO BAY AREA

Jonathan H.X. Lee and
the Center for Lao Studies

ARCADIA
PUBLISHING

Published by Arcadia Publishing
Charleston, South Carolina

Printed in the United States of America

Library of Congress Control Number: 2012936546

For all general information, please contact Arcadia Publishing:
Telephone 843-853-2070
Fax 843-853-0044
E-mail sales@arcadiapublishing.com
For customer service and orders:
Toll-Free 1-888-313-2665

Visit us on the Internet at www.arcadiapublishing.com

*We dedicate this book to all Laotians in the San Francisco Bay Area.*

# CONTENTS

# ACKNOWLEDGMENTS

This volume is the culmination of dedicated work by Khammany Mathavongsy, Phoumy Sayavong, Vinya Sysamouth, and Jonathan H.X. Lee. We wish to thank the following supporters for sharing their lives, histories, stories, and resources with us: Asian Pacific Environmental Network/Laotian Organizing Project, Boon Vong, Bouavanh Syphandone Sydavong, Bounchanh and Hongkkham Thepkaysone, Bounmy and Vongduane Somsanith, Boutsaba Janetvilay and family, Chao Khamluang Nokham and family, Chanthanom Ounkeo, Chris Khamvong Karnsouvong, Houmpheng and Kethmani Banouvong, Iu Mien 12 clans, Ken and Kesa Thirakul and family, Khamkheua and Dee Sayavong and family, Khammany Mathavongsy and family, Khammek Sackdavong and family, Kouichoy and Chaylium Saechao and family, Lao Iu Mien Culture Association (LIMCA), Inc., Lao Women Association of the Bay Area, Laurie Reedsnyder, Marcus Q. Rhinelander, Mey Saechao, Mitchell I. Bonner, Pastor Khamsaeng Keosaeng of Khmu Baptist Church, Phengkio Raxakoul and family, Todd Sanchioni, Phoumy and Khamla Sayavong and family, Oun Thavonekham of Lao Arts and Culture Association, Ray and Brenda Soungpanya and family, Saysombath and Oradee Houngviengkham, Sean Soungpanya and Bouakham Sayavong and family, South East Asian Cultural Heritage and Musical Performing Arts (SEACHAMPA) Project, Sumphun Phinong Lao Association, Vongtakhoun Association, and Wat Lao Rattanaram Temple. Phoumy Sayavong wishes to extend a special thanks to Allan Soungpanya, Linda Soungpanya, Tom Schao, and Seng K. Fong, executive director of Lao Iu Mien Culture Association, Inc. Jonathan H.X. Lee wishes to extend a warm thank you to his students at San Francisco State University, who went into their communities to gather stories and photographs, and Mark E. Pfeifer.

# INTRODUCTION

Contemporary Laos has its roots in the ancient Lao kingdom of Lan Xang, established in the 14th century under King Fa Ngum. For 600 years, Lan Xang, "the Kingdom of a Million Elephants," had political, cultural, and social influences reaching into present-day Thailand as well as over all of modern-day Laos. After centuries of gradual decline, Laos came under the domination of the court of Siam starting in the late 18th century after separating into the three separate kingdoms of Luang Phrabang, Vientiane, and Champassak. In 1827, the king of Vientiane, Chao Anouvong, led a war against Siam to reclaim autonomy for Laos, but his failure sustained the gradual decline. In the late 19th century, Luang Phrabang became a French protectorate under the Franco-Siamese Treaty of 1893, and the rest of Laos came under the direct rule of France. Laos is the only landlocked country in Southeast Asia and is bordered by China, Vietnam, Cambodia, Thailand, and Burma (Myanmar).

Major rebellion against the French colonialists did not begin until after World War II, when Japan, which began having influence over Laos in 1941, finally took full control of the country from the French in March 1944. In 1945, Luang Phrabang prince Chao Phetsarath declared Laos an independent kingdom and formed a group known as the Lao Issara or "Free Lao." Free Lao strongly opposed French occupation on nationalist but not Communist grounds, while some people supported the French because they thought Laos was not ready for complete independence. Chao Phetsarath's half brother Chao Souphanouvong called for armed resistance and sought support from the Viet Minh, an anti-French, nationalist-Communist movement led by Ho Chi Minh. Chao Souphanouvong's political group later became the Communist Pathet Lao or "Lao Nation."

In the 1960s and 1970s, war raged between the United States–backed Royal Lao government and the Pathet Lao, the nationalist-Communist political movement closely associated with the North Vietnamese Communist movement. Known as the American CIA's "Secret War" against the Pathet Lao, the war included a massive bombing campaign in Laos. Between 1962 and 1973, the United States dropped as much as five million tons of cluster bombs on Laos in defiance of the 1962 Geneva Accords that recognized Laos as a neutral zone. The North Vietnamese also blatantly violated the 1962 Geneva Accords. The devastating campaign of 580,000 bombing missions was the equivalent of a planeload of bombs every eight minutes, 24 hours a day, for nine years. By 1973, an estimated 200,000 people had lost their lives in the conflict, and nearly twice as many were wounded.

After violating the 1973 peace agreement that resulted in the establishment of a coalition government in Laos, the Pathet Lao gained control of the country, and by 1975, Laos was rife with internal ethnic strife and had gained the distinction of being the most heavily bombed country in history. Individuals who served in the Royal Lao Army or who were considered a threat to the new Pathet Lao government were subsequently held in the Lao gulag "re-education" labor camps, which were called "seminars" in rural Laos. Some people remained in these camps for well over a decade. Many died from malnutrition, disease, sickness, and/or mistreatment. Those who were

fortunate enough to survive were left with various forms of long-lasting trauma. Some survivors have written vivid accounts of their experiences living in re-education camps that illustrate a dark period in Lao history.

As a result of the Secret War, hundreds of thousands of Laotian refugees, about 10 percent of the population at the time, fled their homeland between 1975 and the early 1990s, with many of them immigrating to the United States. The majority of Laotian refugees who fled Laos spent time in refugee camps in Thailand and the Philippines before settling in countries such as Argentina, Australia, Canada, China, France, French Guiana, Japan, New Zealand, and the United States. These camps held the promise of escape from war but more often delivered a reality of poverty and violence. Some camps were also organizing bases for insurgent groups fighting against the Lao Communists.

The passage of the Indochina Migration and Refugee Assistance Act in 1975 allowed Southeast Asians who had been closely associated with the US military in Vietnam, Laos, and Cambodia entry to the United States. Later on, the Refugee Act of 1980, sponsored by Sen. Edward M. Kennedy and signed into law by Pres. Jimmy Carter, admitted more Southeast Asian refugees, in particular the Sino-Vietnamese "boat people" from Vietnam, Khmer Rouge survivors from Cambodia, and multi-ethnic Laotian refugees of Laos. Many Lao Isan people from Northeast Thailand, a territory once linked to the Lao Lan Xang kingdom, also live in the United States.

Between 1975 and 1979, approximately 22,000 Laotian refugees arrived in the United States. The majority of these earlier refugees were relatives of Laotians who were employed by the US Information Service, the US Agency for International Development, or the US embassy in Vientiane. Between 1979 and 1981, 105,477 refugees arrived in the United States. Additionally, between 1986 and 1989, 52,864 Laotian refugees arrived to the United States. Unlike the first waves, they were mainly farmers and villagers who were not as educated or as ready for life in an urban setting. Laotian refugees continued to immigrate to the United States in the early 1990s, albeit in small numbers.

Refugees from Laos live in geographically diverse communities. The largest concentration lives in California, in particular Sacramento, San Diego, and the San Francisco Bay Area. Other sizable communities live in Texas, Washington, Minnesota, Wisconsin, Illinois, Georgia, Texas, North Carolina, and Oregon. Upon immigration to the United States, Laotian refugees encountered a new culture far different from their own. The land, the language, and the social fabric of their new home stood in sharp contrast to Laos. Many refugees underwent dramatic shifts in socioeconomic status as well as occupation.

In this volume, the use of the term "Laotian" refers to someone who comes from Laos. The word Laotian is problematic and not generally accepted by scholars or people within the diverse communities. Khamchong Luangpraseut differentiates Lao as referring to members of the Lao ethnic group and Laotian as referring to anyone who come from Laos. Luangpraseut's classification is contested for being "Lao-centric." As such, most people from different non-Lao ethnic groups prefer to be called by their own groups' ethnic group names, like Hmong, Iu Mien, Khmu, Tai Dam, Tai Lue, and so on. However, some will clarify by saying they come from Laos or are "Laotian" when speaking to people who are unfamiliar with Laos and its diverse ethnic and cultural groups. The present government in Laos officially recognizes 49 ethnic groups and many more subgroups in Laos. Before 1975, 68 ethnic groups were recognized. The Lao, Tai Dam, and Tai Lue speak languages in the Tai-Kadai linguistic family; the Hmong and Iu Mien speak languages in the Hmong–Iu Mien linguistic family; the Khmu language is in the Mon-Khmer linguistic family; and the Lahu and Akha speak languages in the Tibeto-Burman linguistic family. It is generally recognized that the native peoples of Laos all speak languages and dialects within these four language groups.

# One

# FACTORS OF MIGRATION

After World War II, the United States was concerned that Communism was spreading in Southeast Asia and sent military forces into Vietnam to stop it from spreading. In Laos, American military forces provided tactical and economic support to the royal government to fight the Communist forces. During this period, the United States dropped bombs on the Ho Chi Minh Trail, which runs through Laos and Cambodia, resulting in many civilian causalities and displacement of thousands of Laotian people from their homes. The US bombing campaign dropped more bombs in Laos then both World War I and World War II combined. According to a 1986 report by the US Committee for Refugees, American bombers dropped about 300,000 tons of bombs on Xieng Khouang Province alone. One of the deadly legacies of the clandestine bombing raid is the presence of unexploded cluster bombs, known as "unexploded ordnance" (UXO). Laotians call them "bombies." UXO are explosive weapons (bombs, bullets, shells, grenades, land mines, naval mines, and so on) that did not blow up when they were employed and still pose a risk of detonation, potentially many decades after they were used or discarded. According to the social justice organization Legacy of War, "there are currently over 75 million units of unexploded ordnance in Laos left behind from the Vietnam War." Today, more than three decades after the war, many Laotian people are still dying in the fields and forests of provinces like Xieng Khouang. Farming is now one of the deadliest occupations in Laos.

The United States withdrew its forces in 1973, and Saigon fell to the Viet Cong in April 1975. Later in 1975, the Communist Pathet Lao took control of the government, ending a six-century-old monarchy and instituting a strict Socialist regime closely aligned to Vietnam. The Pathet Lao renamed the country Lao People's Democratic Republic. At this time, thousands of Laotian refugees fled Laos for Thailand as a direct result of the heinous acts of genocide against Hmong and Laotian communities that sided with the monarchy and allies or individuals of royal descent. The Pathet Lao raided Lao and Hmong villagers as an act of reprisal for supporting foreign forces, and concentration camps were established in the northeastern highlands of Laos where prisoners of war and members of the royal family were sent to be tortured and killed.

In Laos, there were small-scale evacuations in May 1975 of about 2,500 Hmong, the highland group who had been recruited into the CIA's not-so-secret Secret War. Over time, however, more refugees from Laos escaped to Thailand. Some, especially ethnic Laotians, merged into the Thai population. Most, however, ended up in refugee camps, with a total population exceeding 70,000 by the end of 1975.

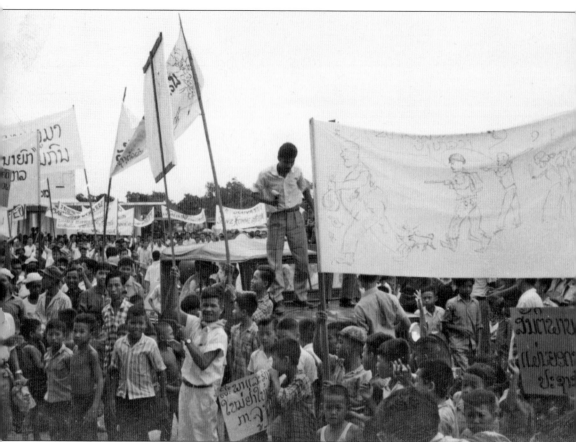

Pictured in 1960, the people of Laos are protesting Kong Le's overthrow of the democratically elected Royal Lao government. (Courtesy of Boutsaba Janetvilay.)

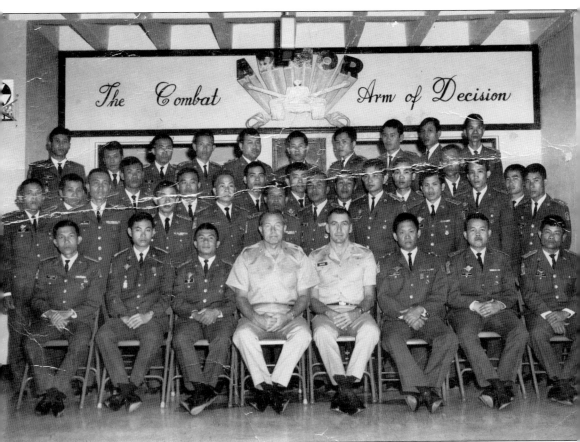

In 1969, First Lt. Khamphou Mathavongsy (second row, fifth from right) was one of 35 Laotian officers being trained at the US Army Armor School at Fort Knox, Kentucky, for the Royal Lao Army. The Royal Lao Army was formed in 1948, soon after the kingdom of Laos adopted its first constitution, elected its first national assembly, and installed a new parliamentary system of government. (Courtesy of the Mathavongsy family.)

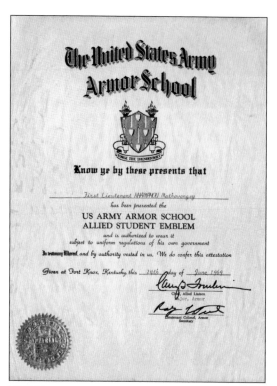

First Lt. Khamphou Mathavongsy received a US Army Armor School Allied Student Emblem in 1969. To meet the threat represented by the Pathet Lao, the Royal Lao Army depended on a small French military training mission that was headed by a general officer, an exceptional arrangement permitted under the Geneva Conventions. Military organization and tactical training reflected French traditions. Most of the equipment was of US origin, however, because early in the First Indochina War, the United States had been supplying the French with matériel ranging from guns to aircraft. (Courtesy of the Mathavongsy family.)

Here is First Lt. Khamphou Mathavongsy's official military identification document while training at the US Army Armor School at Fort Knox, Kentucky, for six months in 1969. (Courtesy of the Mathavongsy family.)

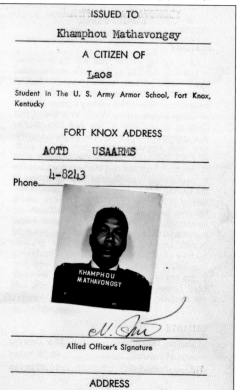

HEADQUARTERS THE U. S. ARMY ARMOR SCHOOL
OFFICE OF THE COMMANDANT
Ft. Knox, Kentucky

Welcome to the U. S. Army Armor School.

While your academic schedule will be a busy one, there will be free time when you will want to visit the nearby environs of the Fort, including the City of Louisville and other Kentucky communities. It is to this end that the Louisville Area Chamber of Commerce has so graciously prepared the following material to assist you.

We urge you to participate in as many civilian community endeavors as you can in order to further enhance your knowledge of American cultural and social life. In becoming better acquainted with our civilian communities you will find this identification of great assistance; particularly in obtaining hotel accommodations, at State parks, restaurants, and other public places where you might feel strange. We trust that your frequent use of this means of introduction will result in the traditional extending of the hand of friendship on many occasions in the future.

Commandant
The U. S. Army Armor School

ISSUED TO

Khamphou Mathavongsy

A CITIZEN OF

Laos

Student in The U. S. Army Armor School, Fort Knox, Kentucky

FORT KNOX ADDRESS

AOTD      USAARMS

Phone  4-8243

KHAMPHOU MATHAVONGSY

Allied Officer's Signature

ADDRESS

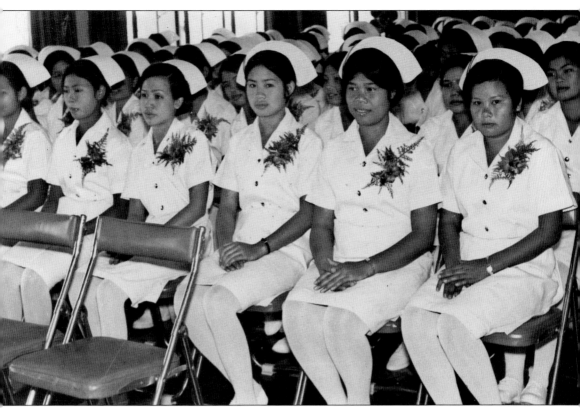

Post–World War II reconstruction in Europe was a success. Inspired by the Marshall Plan and the Truman administration's Point Four Program, Pres. John F. Kennedy signed the Foreign Assistance Act into law in 1961, and the US Agency for International Development (USAID) was created by executive order. USAID has served as the main US agency to extend assistance to countries engaging in democratic reforms, recovering from natural disasters, and/or seeking economic development out of poverty. One direct implication of USAID's work is furthering America's interests while improving people's lives in the developing world. One example of USAID work is the funding and training of Laotian nurses, who were trained in Thailand. In this photograph are nurses in the 1970 graduation class. The United States provided economic assistance through USAID programs between 1962 and 1972. (Courtesy of the Thirakul family.)

Tiao (Lao for princess) Marina Rangsi is currently living in exile in France. Among Laotians, Tiao Rangsi epitomizes the grace, poise, and cultural education of a Lao woman during the 1960s. Tiao Rangsi was appointed the director of the Home Economic Extension of the Department of Agriculture of the Royal Lao government. This photograph was given to her classmate Kesa Thirakul during the USAID nurses' training in Thailand in 1968. (Courtesy of the Thirakul family.)

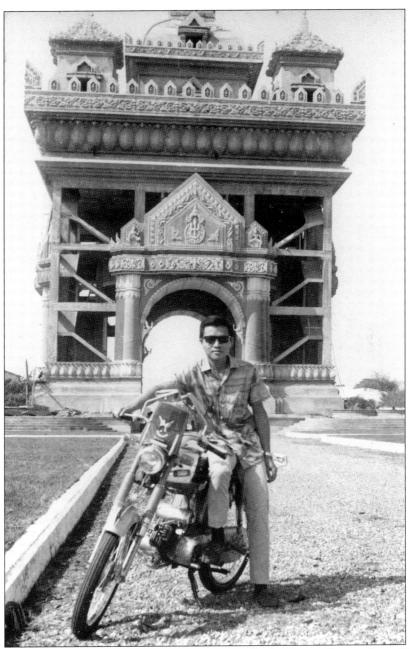

Ken Thirakul is pictured in 1967 in front of Patuxai, literally the Victory Gate or Gate of Triumph, formerly the Anousavary or Anosavari Monument. Built in 1962, it is a monument in the center of Vientiane, Laos. The monument is dedicated to those who fought to free Laos from colonial France. Although it bears a general resemblance to the Arc de Triomphe in Paris, it is typically Laotian in style, decorated with many *kinnari* figures. The monument is situated on Lan Xang Boulevard (sometimes known in Lao as Thanon Luang, meaning "Grand Avenue or Street"), which has been called the "Champs Elysées of the East." US funds allocated for the construction of the Wattai Airport's runway were used to build this monument, which is why it is sometimes referred to as the "Vertical Runway." (Courtesy of the Thirakul family.)

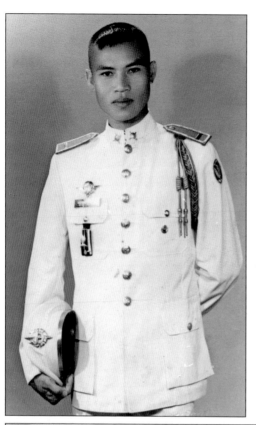

A member of the 25th graduating class, 24-year-old officer Phengkio Raxakoul is seen in the Royal Lao Military Academy uniform in 1971. The predecessor of the Royal Lao Army was the National Laotian Army (NLA) of the French Union, created in 1947 from the Maquis, or guerrilla units, gathered by French commandos. It was created in 1954 after the French granted Laos complete autonomy. By July 1959, it was known as Forces Armée Laotienne, and in September 1961, it was renamed Royal Armed Forces. (Courtesy of the Raxakoul family.)

Here is officer Phengkio Raxokoul's Royal Lao Army driver's license, issued in 1973. (Courtesy of the Raxakoul family.)

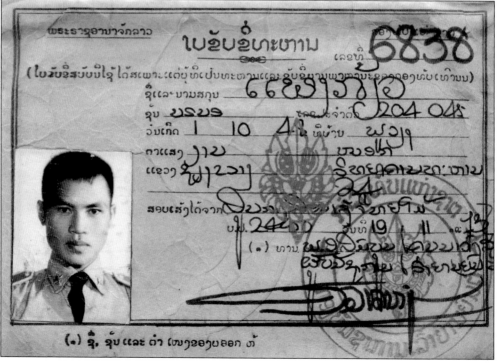

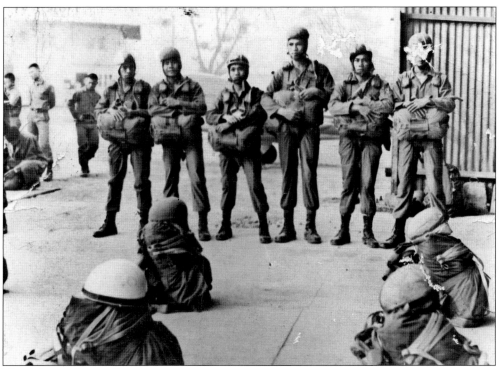

Third from right is officer Phengkio Raxakoul at the Commando Training Center in Udonthani Province, Thailand. Officer Raxakoul was trained by US military advisors based in Thailand to collect war intelligence in 1973. The training program lasted six months. (Courtesy of the Raxakoul family.)

Former police colonel Chao Khamlouang Nokham is pictured in 1975 at age 35 serving with the Royal Lao Police; he currently resides in Pinole, California. (Courtesy of the Nokham family.)

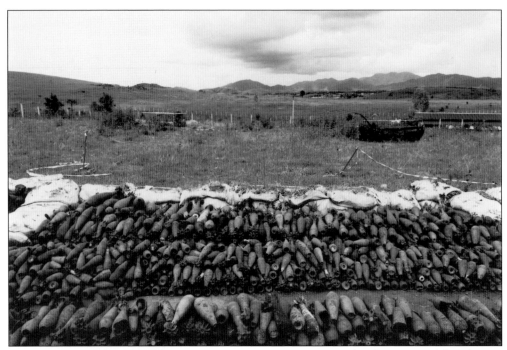

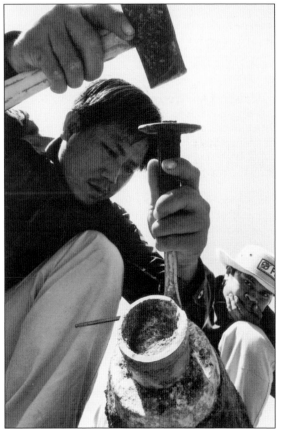

Here is a pile of scrap metal found outside of Phonsavanh in Xieng Khouang Province, Laos. The metal gets recycled and mostly purchased by neighboring Vietnamese traders. Some of the piles were actually live ordnance as of 2008. (Courtesy of Boon Vong.)

A bomb disposal technician from the nonprofit Swiss Foundation for Mine Action removes the nose fuse from an unexploded American bomb near Xepon, Savannakhet, in 2006. (Courtesy of Marcus Q. Rhinelander.)

# Two

# RESETTLEMENT

The Laotian refugee resettlement effort reflected the work of voluntary agencies, individual citizens, and federal, state, and local governments, all working together to assist the new arrivals in adjusting to American society. Voluntary agencies (known as "volags"), such as the US Catholic Conference, the International Rescue Committee, and Church World Service, arranged sponsorships for the refugees and took care of their initial needs upon arriving in the United States. Many church groups, corporations, and individuals became sponsors for refugee families, providing housing, food, and clothing until these families were able to live independently.

The Refugee Act of 1980 created the Office of Refugee Resettlement, which administers programs and services for refugees within the United States. Individual states play a central role in the resettlement process and are required to have a plan for refugee assistance in order to receive federal funding. Similarly, certain federal programs, such as targeted assistance grants, are administered at the county level.

Adjusting to their new life in America was not easy. Many Laotian refugees were farmers, with a sizable portion of them being illiterate and unskilled. Thus, many suffered from culture shock. As such, seeking employment was challenging because of the language barriers, which made it more difficult to culturally and structurally integrate into American society. Laotian social structures and folkways had to be altered to adjust to their new realities: the extended clan-based hierarchy, for example, did not transfer over because family units were broken as a result of war and displacement. Moreover, collective identities and the collective ethos of Laotian society clashed with the American ethics of individualism. Laotian women had more power, socially and economically, in the United States, which influenced the gender dynamics of Laotian American families. Thirty plus years later, Laotian Americans are still actively engaged in resettlement and adjustment work.

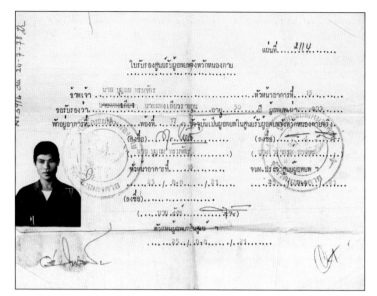

Here is Phengkio Raxakoul's underground resistance movement identification document while at Nong Khai Refugee Camp between 1975 and 1978, issued by the Kingdom of Thailand's Ministry of the Interior. (Courtesy of the Raxakoul family.)

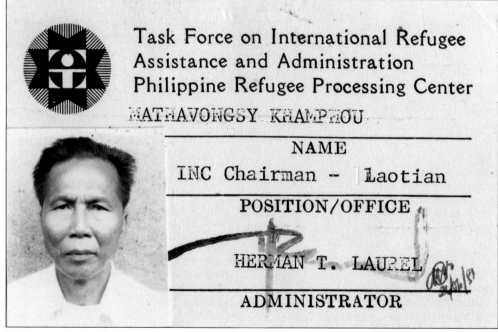

Before coming to the United States, many Laotian refugees stopped at the Philippine Refugee Processing Center (PRPC) near Morong, Bataan. It opened in 1980 and served Vietnamese, Cambodian, and Laotian refugees. The PRPC was funded by the United Nations High Commissioner for Refugees and was able to host and process up to 18,000 refugees at any given time. While in resident at the PRPC, Laotian refugees had English lessons and were introduced to aspects of American society and culture. Those who were bilingual were employed to assist their fellow countrymen. Mathavongsy Khamphou assisted other Laotian refugees while at PRPC in 1989. (Courtesy of Khammany Mathavongsy.)

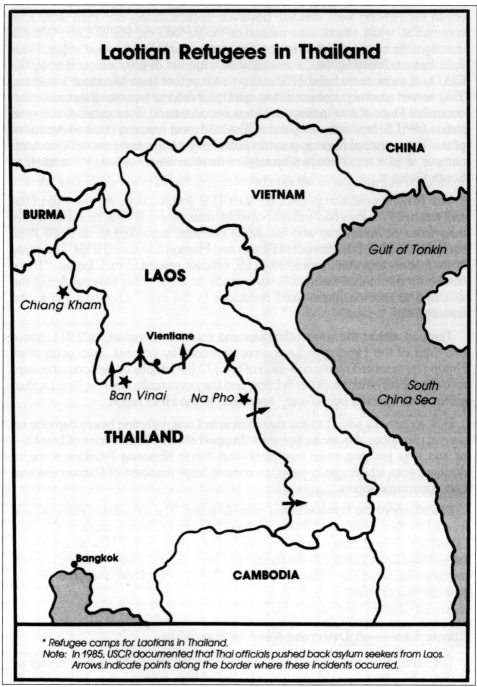

## Laotian Refugees in Thailand

CHINA

VIETNAM

BURMA

Gulf of Tonkin

LAOS

Chiang Kham ★

Vientiane

Ban Vinai ★

Na Pho ★

South China Sea

THAILAND

Bangkok ●

CAMBODIA

\* Refugee camps for Laotians in Thailand.
Note: In 1985, USCR documented that Thai officials pushed back asylum seekers from Laos. Arrows indicate points along the border where these incidents occurred.

The United Nations High Commissioner for Refugees and the Thai government supported the refugee camps in Northern Thailand. There were many refugee camps setup along the provincial border between Thailand and Laos to handle and process the large number of refugees from Laos, Cambodia, and Vietnam who escaped on land rather than in boats. As one of the first countries to offer asylum, Thailand started to push refugees back, as indicated in the map. (Courtesy of the US Committee for Refugees.)

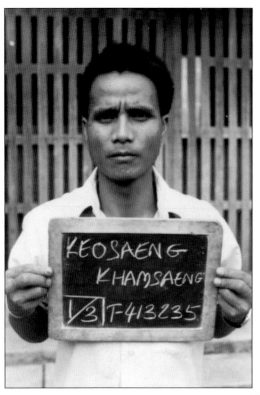

Here is Khamsaeng Keosaeng's refugee identification photograph. Almost all Laotian American families will have one or more copies of their refugee identification photographs. These are the Keosaeng family members' refugee identification photographs taken at Phanat Nikhom Refugee Camp, Thailand, in 1986, one month before their departure to San Francisco, California. The entire family resettled in Richmond, California. Khamsaeng Keosaeng is now an ordained pastor for the Khmu Baptist Church in Richmond. (Courtesy of the Keosaeng family.)

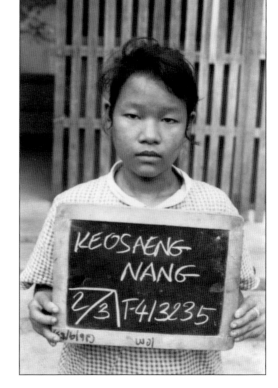

Nang Keosaeng is Khamsaeng Keosaeng's wife and is active with the Khmu Women Association. (Courtesy of the Keosaeng family.)

Today, Saengthip Keosaeng is 26 years old and a graduate the San Francisco Culinary Academy. Saengthip works at an Italian restaurant in San Francisco. She is also interested in social and environmental justice issues effecting Laotian Americans. She was an active member of Asian Youth Advocates (AYA) with Asian Pacific Environmental Network/ Laotian Organizing Project (LOP) in Richmond, California, which promotes affordable housing and advocates against unjust evictions of low-income renters in Richmond. She volunteers at the Khmu Baptist Church; Khmu National Federation, which organizes the National Khmu Youth and Education Conference; and Banteay Srei, a Khmer women's empowerment project in Oakland, California. (Courtesy of the Keosaeng family.)

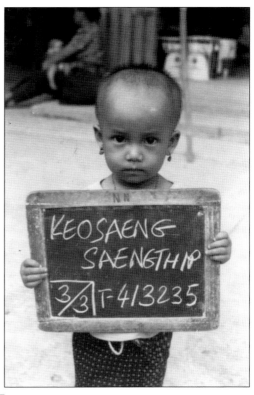

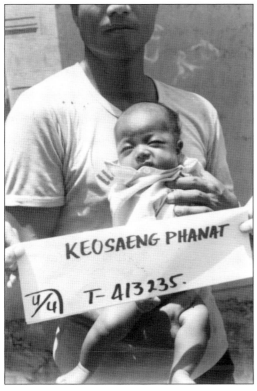

Phanat Keosaeng is the youngest son of Khamsaeng and Nang Keosaeng. Today, he is 24 years old. After graduating from El Cerrito High School, he worked in the manufacturing sector. He is also active in the Khmu Baptist Church in Richmond and volunteers with the Khmu American Youth in San Francisco Bay Area. (Courtesy of the Keosaeng family.)

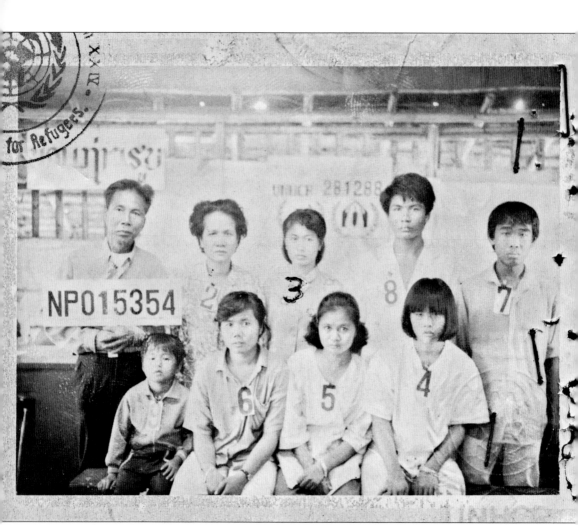

Here is the Mathavongsy family's United Nations High Commissioner for Refugees (UNHCR) identification photograph with information. It was taken on December 28, 1988. "NP" denotes Napho Refugee Camp in Thailand, and 015354 is the case number assigned by UNHCR officials. This document was used for processing at the refugee camps and once the family arrived in the San Francisco Bay Area. They arrived at San Francisco International Airport on October 17, 1989—the same day as the Loma Prieta Earthquake. The family lives in west Contra Costa County, California. (Courtesy of the Mathavongsy family.)

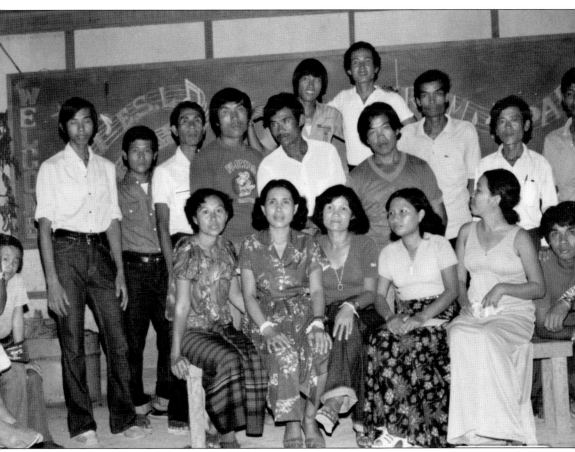

In preparation for their final journey to the United States, Laotian refugees at the Philippine Refugee Processing Center in Bataan took advance English as a second language (ESL) classes. Sousiva Janetvilay, pictured on far left in the first row, and her classmates are celebrating their last day of class in 1980. (Courtesy of Boutsaba Janetvilay.)

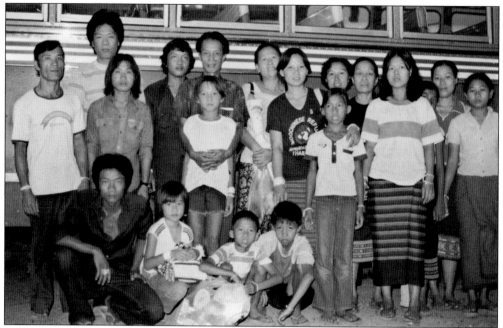

Pictured at Nong Khai Refugee Camp in Thailand in 1980, three refugee siblings, Ketsomchay (second from the left in the first row), her brother Loy (being hugged by their father), and Ketvilay Soumpholphakdy (resting her hand on the shoulder of their little cousin Pinmany Janetvilay in the second row), are departing to join their older sister in San Francisco. The travelers are wearing white bracelets indicating the performance of a *baci* ceremony to protect them on their journey. (Courtesy of Boutsaba Janetvilay.)

Samly Sackdavong and her sons, Chanthavy (back) and Chanthala, are pictured at the Ubonrajthani Refugee Camp, Thailand, in 1980, operating a makeshift pharmacy inside the camp. According to Mitchell I. Bonner, "The Thai government provides rice and some vegetables [for the Laotian refugees]. Other items have to be bought from stores in the camp. Some refugees with money have been allowed by the camp guards to set up businesses." (Courtesy of the Khammek Sackdavong family.)

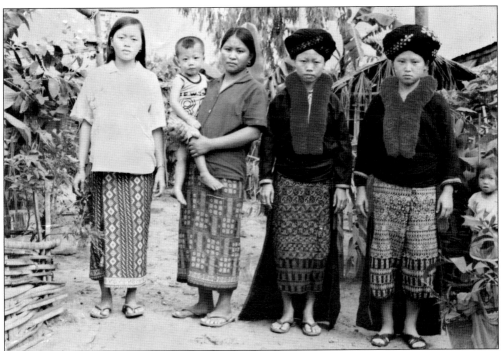

Nai Saefong is pictured second from the right in traditional Iu Mien clothing in a refugee camp in Thailand in 1986. Mitchell I. Bonner, a former refugee relief worker, describes life at Nong Khai Refugee Camp as follows: "The Lao have little to do in the camp. They eat, sleep, and kill time. Some learn English in make-shift schools in the camp. An international religious organization has constructed a school for teaching English to children. Many people kill time by playing soccer, *tekaw* (a game played with three-man teams and a rattan ball. The teams try to hit the ball over a volleyball net using any part of their body but their hands), or socializing with friends. Some people rent sewing machines from the Singer Sewing Center in Nong Khai to make clothing. Some Lao can get passes to visit Nong Khai or go fishing in the Mekong River." (Courtesy of Mey Saechao.)

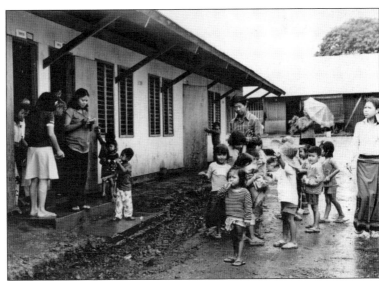

Here is a classroom where Laotian refugees received lessons on English, American culture, and what to expect in the United States at the Philippine Refugee Processing Center in Bataan, Philippines, in 1980. (Courtesy of Laurie Reemsnyder.)

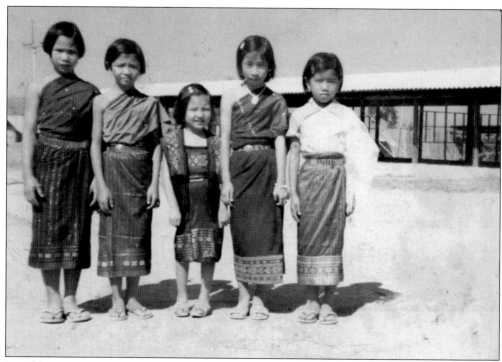

Bouakham Sayavong, pictured on the right, is with her friends in at the Ban Thong Refugee Camp at the Thailand-Laos boarder in Thailand in 1977. They are dressed in traditional Lao silk clothes. (Courtesy of Bouakham Sayavong.)

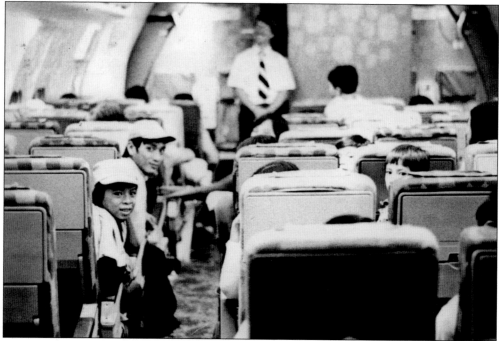

Laotian refugees are shown leaving the refugee camps on a charter flight heading to the United States in 1980. For many, this is their first time in an aircraft. (Courtesy of Laurie Reemsnyder.)

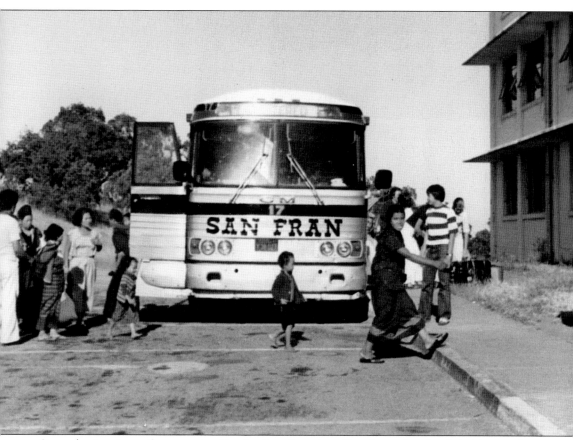

Once the Laotian refugees arrived in the San Francisco Bay Area, they landed either at the Oakland Airport or at Travis Air Force Base. From there, they rode on a charter bus that took them to Hamilton Field. At Hamilton Field, they were processed and then relocated to their final destination within a few days. (Courtesy of Laurie Reemsnyder.)

Hamilton Field is a former Air Force base in Navato, California. Its deactivation coincided with the end of the Vietnam War, and the base was then used as a resettlement and processing center for refugees from Vietnam, Laos, and Cambodia. Over 180,000 refugees passed through Hamilton Field in the early 1980s. (Courtesy of Laurie Reemsnyder.)

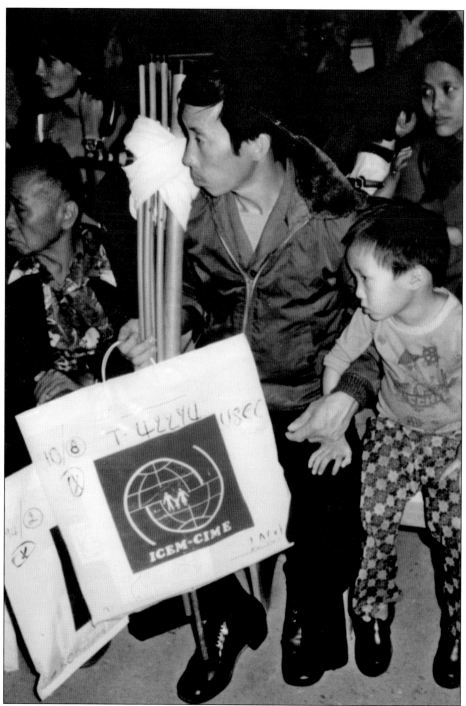

A newly arrived Hmong refugee and his son are at an orientation at Hamilton Field Transit Center in 1980. It is estimated that more than 90,000 Hmong refugees had resettled in the United States by 1990, with 6,000 in France and 3,000 in Canada, Australia, Argentina, and French Guiana. According to the 2010 US Census, there are 260,073 self-identified Hmong people living in the United States. (Courtesy of Mitchell I. Bonner.)

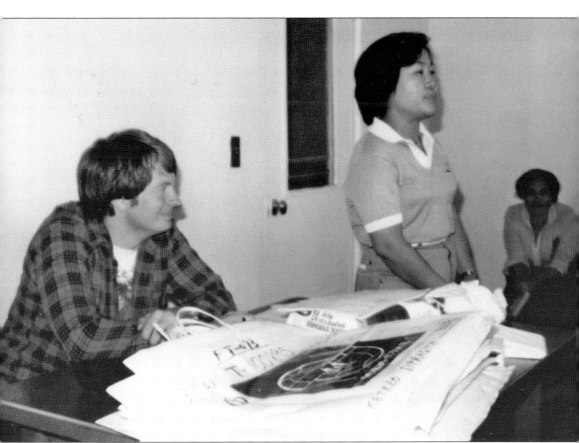

An International Committee of Migration (ICM) staff member and Bouakham (Betsy) Saycocie-Intaracanchit are telling new arrivals the rules and procedures to follow while they stay at Hamilton Transit Center in 1980. The ICM, an United Nations refugee agency contracted by the US government to handle the processing and transportation of Indochinese refugees from Southeast Asia to the United States, then turned them over to the local voluntary agencies in the United States for resettlement. (Courtesy of Mitchell I. Bonner.)

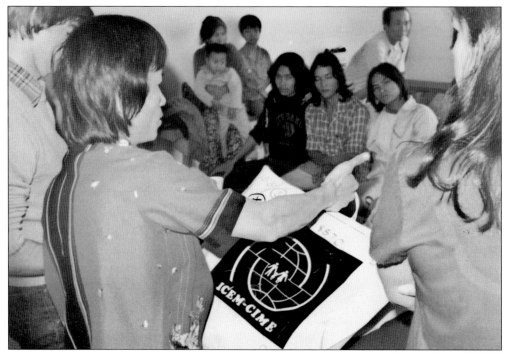

Vath Teso is collecting the ICM bags containing refugee medical records for processing and checking at Hamilton Field in 1980. (Courtesy of Mitchell I. Bonner.)

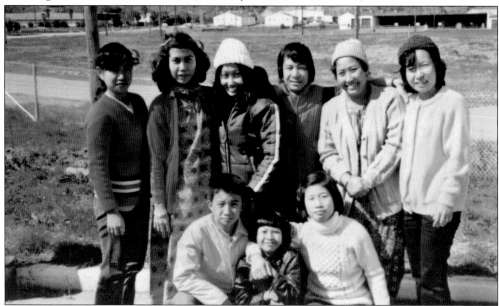

Among the refugees from Vietnam, Cambodia, and Laos, many were ethnic Chinese who were driven out due to ethnic cleansing campaigns. The Chinese Lao refugees, the Chinese Vietnamese, and Chinese Cambodian refugees enrich the diversity within the Chinese American communities. Their bilingual and bicultural abilities allow them to use Chinese American resources in their resettlement. Here, a group of refugee Chinese Lao women rely on each other for support at Hamilton Field in 1980. (Courtesy of Mitchell I. Bonner.)

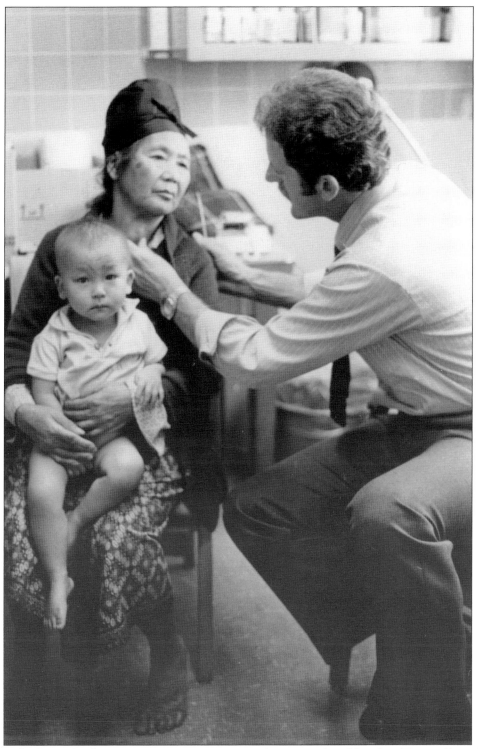

Dr. Charles Hofstadter is examining new Laotian refugee arrivals at Hamilton Transit Center's medical clinic in 1980. (Courtesy of Laurie Reemsnyder.)

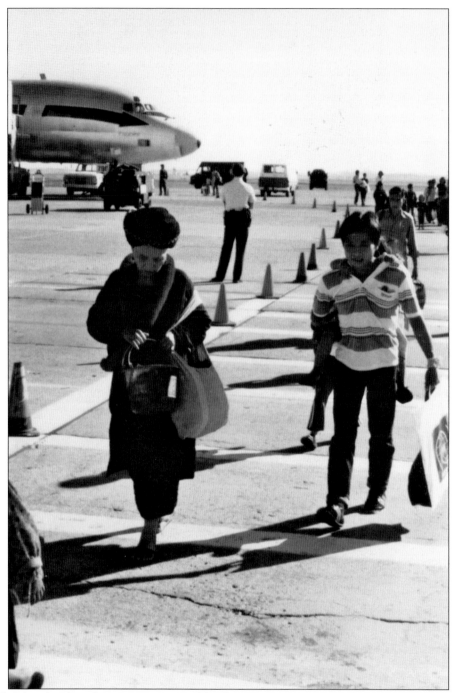

An Iu Mien family is shown arriving at Oakland Airport in 1980. From there, the family is taken to Hamilton Field to be processed and then will travel to its final resettlement location. The resettlement policy at this time wanted to limit the economic impact to any one particular state or local community, so the refugees were dispersed to all 50 states. Today, many critique this decision because it intensified the refugees' alienation, which could have been lessened if they were settled together in larger numbers. (Courtesy of Laurie Reemsnyder.)

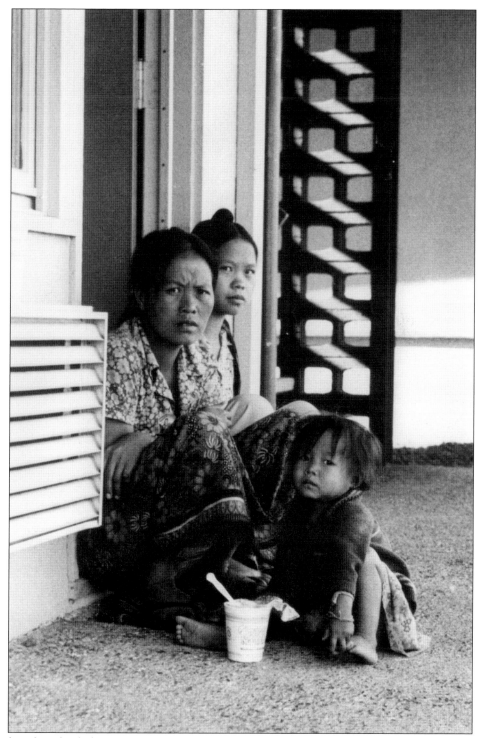

Before their final placement, refugees undergo a health screening. If they have a health problem, they will be quarantined until it is cleared. A Laotian family is placed on medical hold at the Travelodge motel in South San Francisco in late 1979. (Courtesy of Laurie Reemsnyder.)

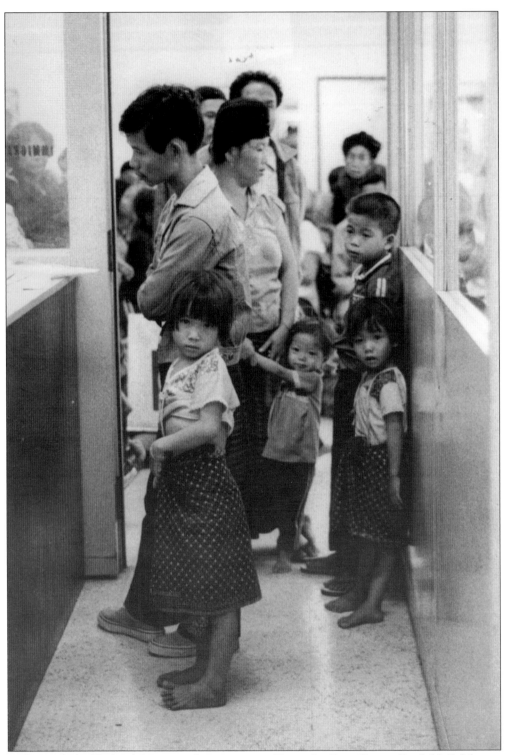

A charter flight filled with Laotian refugees arrives at Travis Air Force Base in Fairfield, California, in late 1979. (Courtesy of Laurie Reemsnyder.)

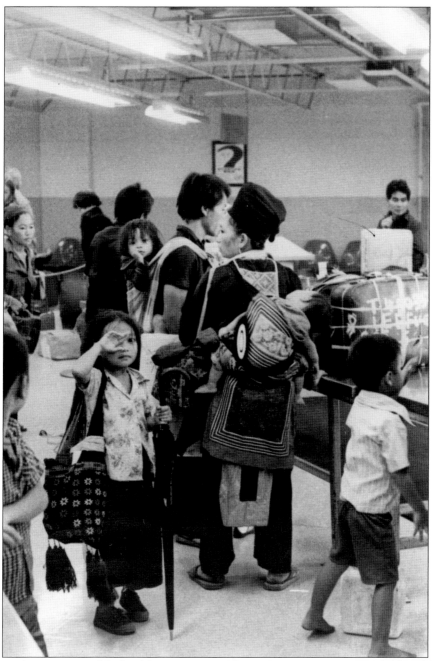

Hmong refugees await public health screenings at Travis Air Force Base in Fairfield, California, in late 1979. The origin of the Hmong can be traced back to the southeastern region of China as early as 2240 BC. Political turmoil and climate change eventually forced the Hmong to migrate south into mainland Southeast Asia, but over a million Hmong still occupy parts of China today. The Hmong are also known as the "Yao," but that term has been rejected due to its derogatory connotations. A large concentration of the Hmong can be found in the mountainous region of Laos, where they plant rice, corn, and other vegetables and also raised livestock to survive. (Courtesy of Laurie Reemsnyder.)

Laotian, Vietnamese, and Cambodian refugees are waiting to be processed at Travis Air Force

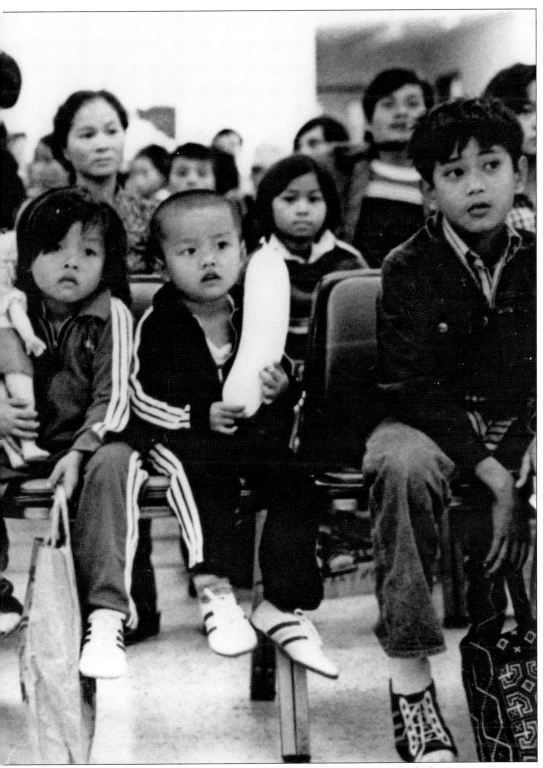

Base in Fairfield, California, in late 1979. (Courtesy of Laurie Reemsnyder.)

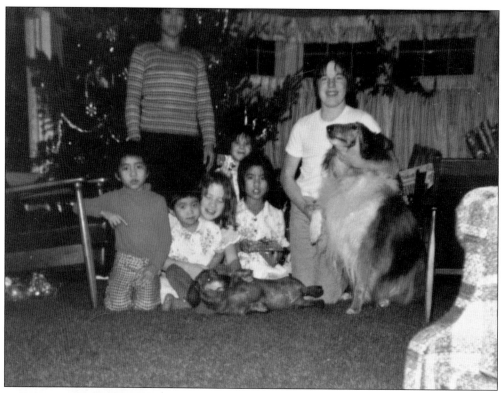

The Sayavong family is pictured with its sponsors in Seattle in December 1979. The Sayavong family of eight lived with its sponsor's family of five for several months. Pictured are, from left to right, (first row) Phoumy, See Wai, Gayle, Bouakham, and Sean; (second row) Dee Sayavong and Megan. (Courtesy of Phoumy Sayavong.)

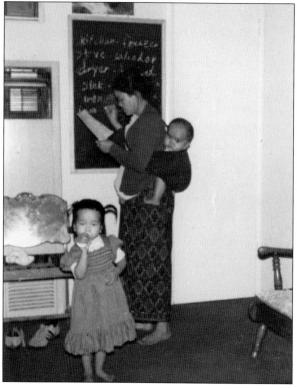

Brenda Soungpanya, with son Thone and daughter Diana, is learning English at home in Richmond, California, in 1981. (Courtesy of Brenda and Linda Soungpanya.)

Three of the Soungpanya kids attended elementary school with Vietnamese and Cambodian refugee children in Richmond, California, in 1981. Wearing the Mickey Mouse T-shirt is Pheng Soungpanya. The two boys on the left are Pon (next to the teach at top) and Leck Soungpanya (far left). (Courtesy of Brenda and Linda Soungpanya.)

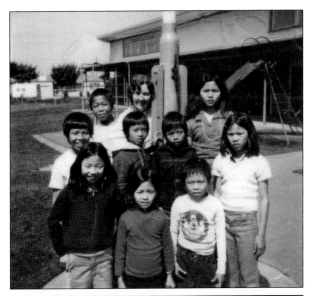

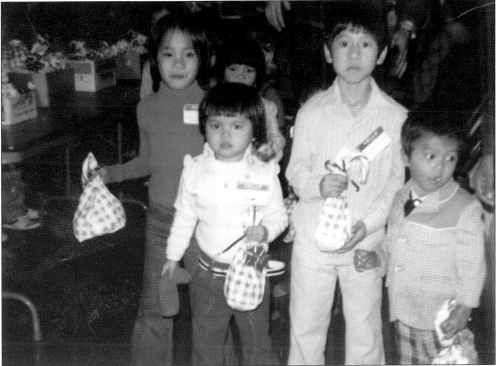

While in the refugee camps, Catholic relief workers are not supposed to evangelize to the refugee populations. However, a considerable number of refugees will convert to Catholicism; some do it out of respect and feel it is a way to express gratitude. Scholars have called such converts "rice-bowl Christians." Once they are resettled and there is a semblance of normalcy, some of the converts will reconvert back to their heritage tradition, Buddhism, while others will meld Christian and Buddhist practices together. From left to right, Amy Vongthavady, Linda Soungpanya, Leo Inpraseuth, and Somphet Inpraseuth are at a Catholic church in Richmond, California, during Christmas in the early 1980s. (Courtesy of Brenda and Linda Soungpanya.)

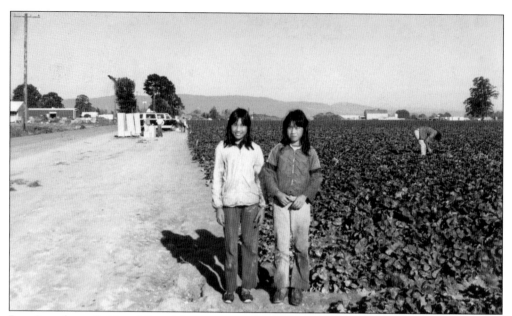

Pam Somphone (left) and Seng Manixay are picking strawberries in Vancouver, Washington, in 1983. In the late 1980s, they relocated to the San Francisco Bay Area to be closer to relatives, friends, and other Laotian refugees. (Courtesy of Bouakham Sayavong.)

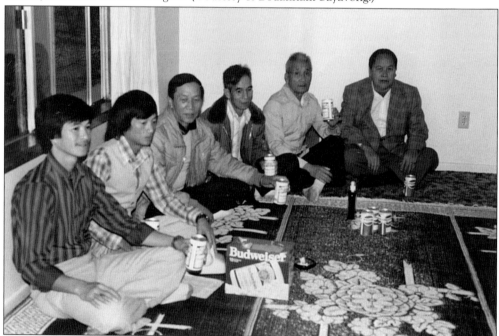

Social gatherings among relatives and friends who used to live in the same village back in Laos are very common among Lao refugees living in America. Their conversations usually include topics and stories dating back to when they were in Laos and stories of how they have accommodated to living in the United States. The social gathering took place at Phaya Nuphet's home in Richmond, California, in 1986. From left to right are Khamsao Sipanya, Noi Sayavong, Khamkheua Sayavong, Pin Sipanya, Bounkhua Sayavong, and Phaya Nuphet. (Courtesy of Khamkheua Sayavong.)

After settling into their new home, Laotian refugees must navigate American institutions to enroll their children in schools, and get public health insurance, welfare benefits, and other documents that allows them to live in the United States. Those who are bilingual become important figures, as they assist fellow refugees as translators. Here, Bouttry Janetvilay (first row, second from right) assists fellow Laotian refugees obtain their green cards in San Francisco's Tenderloin neighborhood in 1983. (Courtesy of Boutsaba Janetvilay.)

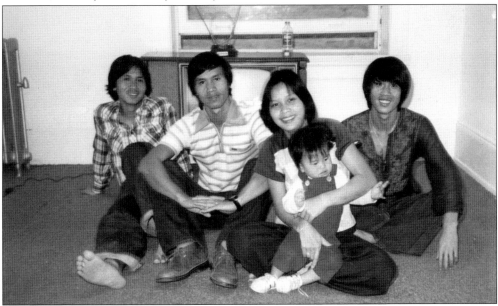

Here, newly arrived refugees from Ban Thong Refugee Camp at the Thailand-Laos boarder have settled in their first apartment in San Francisco's Nob Hill neighborhood in 1978. From left to right are Phou Banouvong, Houmpheng Banouvong, Kethmani Banouvong with her son Ariyakone Banouvong, and Van Sy Banouvong. (Courtesy of the Banouvong family.)

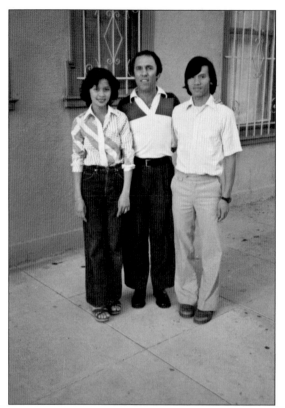

Former USAID officer William Sage visits the Banouvong family in San Francisco seven months after their arrival in 1978. Laotian refugees who had American acquaintances received much needed assistance in adapting to life in the United States. From left to right are Kethmani Banouvong, William Sage, and Houmpheng Banouvong. (Courtesy of the Banouvong family.)

The Sackdavong family is seen in its first apartment in San Francisco's Western Addition neighborhood around 1985. From left to right are (first row) Samly and her husband, Khammek; (second row) Chanthalangsy, Chanthavy, Khanthaly, Kinnaly, and Chanthala. (Courtesy of the Sackdavong family.)

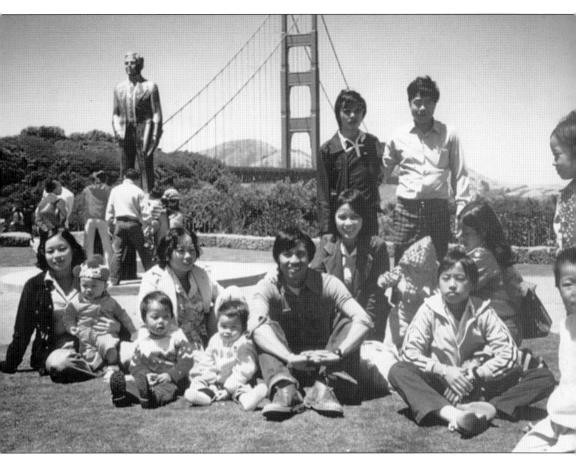

The families of Bounsy Vilaysack, Houmpheng Banouvong, and Kouichoy Saechao are visiting the Golden Gate Bridge in 1978. Laotian refugees take photographs at the Golden Gate Bridge to send to their relatives in Laos or in refugee camps in Thailand and the Philippines to let their loved ones know they survived and are doing well. The bridge communicates life in a new land. (Courtesy of Kouichoy Saechao.)

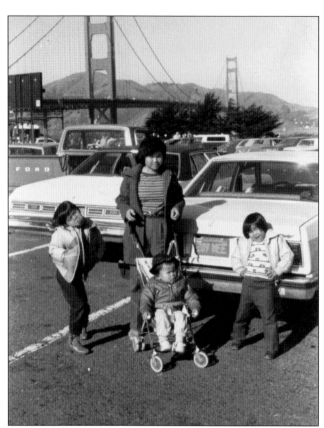

Brenda Soungpanya, with her kids, from left to right, Linda, Thone, and Diana, is visiting the Golden Gate Bridge in 1982. (Courtesy of Brenda Soungpanya.)

After delivering the Sunday newspaper, these Laotian teens explore their new city in 1983. From left to right are Sarathy Janetvilay, Chanthavy Sackdavong, Somaack Sirivath, Kongchanh Moeya, Loy Soumpholphakdy, and Thae Sirivath. (Courtesy of Boutsaba Janetvilay.)

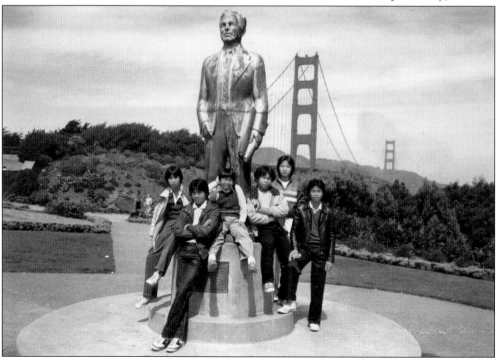

# *Three*

# FAMILIES AND WEDDINGS

In Laos and in Laotian American communities, the Laotian family structure is patrilineal and extended. Descent is traced through the male line. In Laos, men represent their families in village affairs. Women are responsible for taking care of the domestic space and maintaining and controlling the families' financial affairs. Among Laotian Americans, women are employed and have become the more dominant source of income that supports their families. It is also very common for Laotian American women to work outside their home, but this does not mean that they are not responsible for the care and smooth running of the household. Unlike in Laos, more Laotian American men share in the responsibility of taking care of the households, which includes the upbringing of the kids and the completion of chores. Both Laotian American men and women are active in leadership positions in the community.

Laotian American family structures tend to be extended and close. Laotian Americans often live within close proximity to their extended kin. Laotian parents in America often romanticize about how everyone in the village in Laos will help raise their children, which for some does not exist in the United States. As such, they see the plight of some Laotian American youths as a direct result of the lack of a strong family and network within the Laotian American community. Respect for one's elders, especially one's parents, is central to Laotian American family and community.

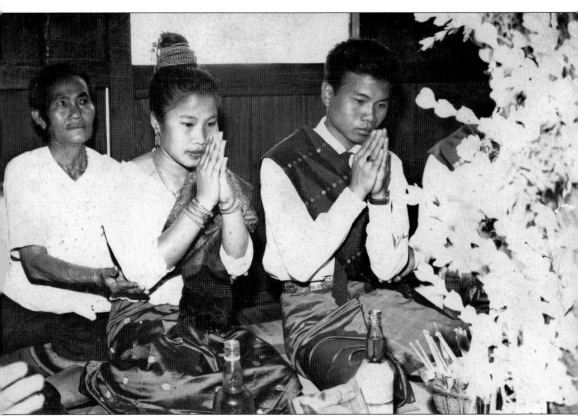

Here, 24-year-old Khammek Sackdavong (right) and 20-year-old Samly are sitting in front for the ceremonial baci bouquet receiving blessing from the *maw ponh* during their wedding ceremony in Pakse, Laos, in 1968. Baci is an important ritual in Lao culture. It is an animist ritual used to celebrate important events and occasions, like births, marriages, entering the monkhood, departing and returning home after an extended period away, and the beginning a new year. In the United States, it is performed for graduation ceremonies in addition to other life achievements. The ritual of the baci involves tying strings around a person's wrist to preserve good luck; it has become a national custom. (Courtesy of the Sackdavong family.)

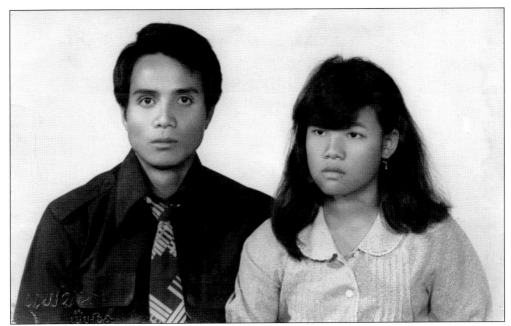

The Khmu couple Khamsaeng and Nang Keosaeng are seen before their wedding in 1984. The Khmu are indigenous to Laos. There are over 400,000 Khmu located in the northern region of the country, and the largest concentration can be found in Luang Prabang. The Khmu occupy parts of Thailand, Vietnam, and China, as well. Like many other ethnic minorities in the region, written history is limited, if not nonexistent, up until 1950. However, the Khmu have maintained various aspects of their culture and history with their strong oral traditions. (Courtesy of the Keosaeng family.)

Ken Thirakul is a respected Laotian elder in the community. This is Ken's family photograph. From left to right are Khemma (brother), Ken's niece, Khamma (mother), and Ken. Today, his niece still lives in Vientiane, Laos. Ken's brother and mother have passed. (Courtesy of the Thirakul family.)

Here is Hongkham Thepkaysone in 1975 at the age of 15. The photograph was taken in Laos at a photography store near a popular cinema. At the time, Hongkham attended Leoto Chinese High School in Vientiane because she is ethnically Chinese. Traditionally, Chinese families in Laos were very conservative and did not marry outside of their ethnic group. After settling in the United States, many became more open to interracial marriages, such as Lao-Chinese couples. (Courtesy of Bounchanh Thepkaysone.)

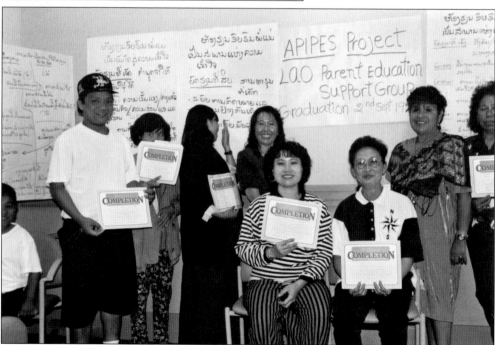

In San Francisco in the 1990s, Laotian refugees are given parenting classes. Topics include hygiene, nutrition, American cultural norms, and expectations. (Courtesy of Chanthanom Ounkeo.)

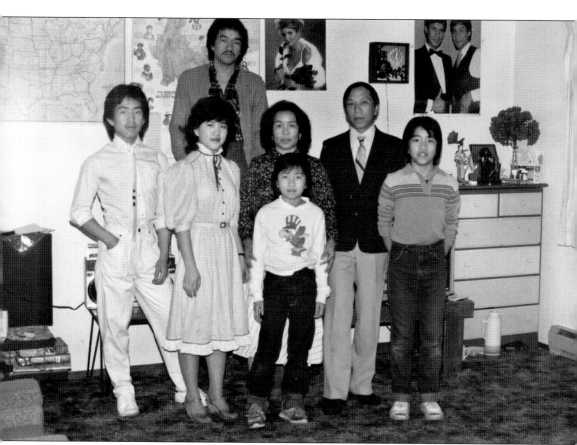

The Sayavong family is pictured in Vancouver, Washington, before the second migration to the San Francisco Bay Area in 1986. From left to right are Jimmy, Bouakham, Seng (back), Dee, SeeWai, Khamkheua, and Phoumy Sayavong. (Courtesy of Khamkheua Sayavong.)

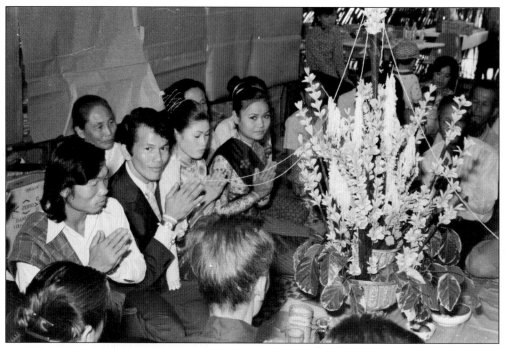

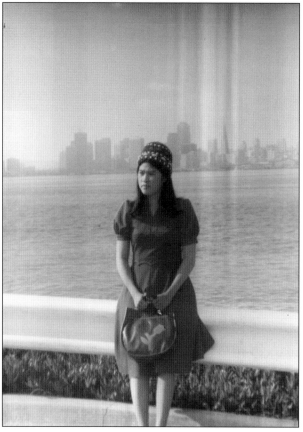

Leaders in their community, Lao Isan Pradith Mata Siharath (second from left) and Lao Chinese Yu Lan Siharath (second from right) are at their wedding in Vientiane, Laos, in December 1974. Shortly after their wedding, they migrated to America with their son, Mangkharath Siharath. They have a successful child day care business in San Francisco and continue to maintain strong ties with their family in Laos and Thailand. (Courtesy of the Siharath family.)

Yu Lan Siharath is all dressed up and exploring her new home in San Francisco, California, in 1976. (Courtesy of the Siharath family.)

Pradith Mata Siharath and Yu Lan
Siharath, with their Laos-born son
Mangkharath Siharath and American-
born daughter Sandra, are at the Palace of
Fine Arts in San Francisco, California, in
1981. (Courtesy of the Siharath family.)

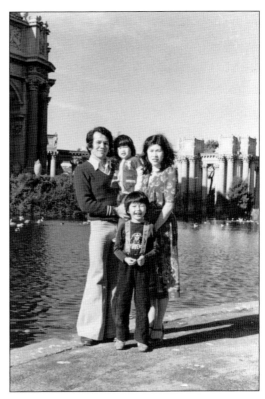

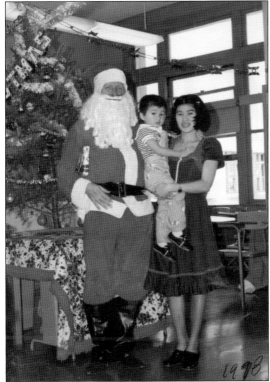

Yu Lan Siharath and son Mangkharath
Siharath celebrate Christmas with
Santa Claus in 1978. Although
members of the Siharath family are
Buddhist, they adapted to celebrating
Christmas for their children as a means
to acculturate to American traditions.
(Courtesy of the Siharath family.)

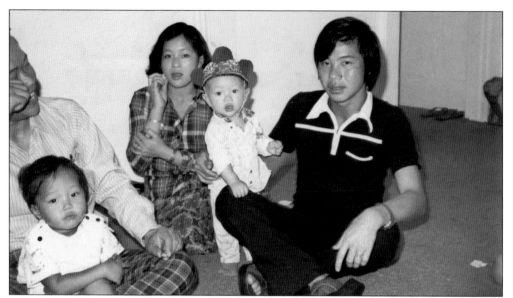

Kouichoy Saechao and his family are pictured in an apartment in San Francisco's Tenderloin neighborhood in 1978. They were among the first group of Laotian refugees to be resettled in the United States. The Tenderloin neighborhood is economically depressed and is known as a place for prostitutes and drug addicts. Children who grow up in the Tenderloin are underserved and underprivileged and are therefore less likely to graduate high school and attend college. (Courtesy of Kouichoy Saechao.)

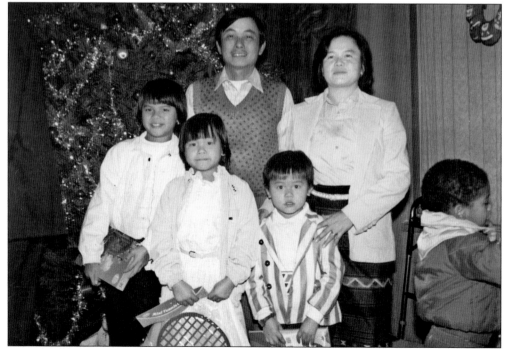

Ray Sounpanya's family is at a company Christmas party in the mid-1980s. From left to right are (first row) Linda, Diana, and Thone; (second row) Ray and his wife, Brenda Sounpanya. (Courtesy of Brenda and Linda Soungpanya.)

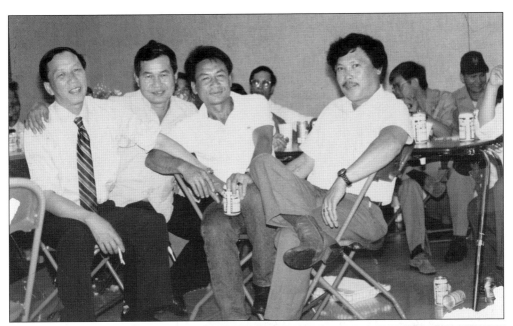

Khamkheua Sayavong (far left) and friends are at a community party in Richmond, California, in 1989. (Courtesy of Khamkheua Sayavong.)

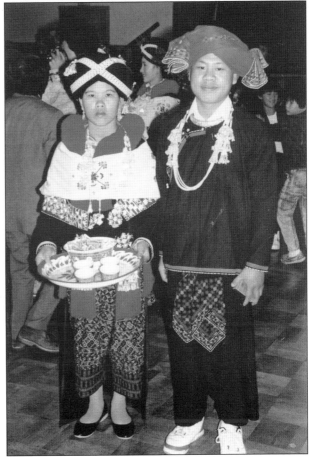

Here are an Iu Mien bride and groom in Oakland, California, in 1980. Although the Iu Mien have been in Laos for quite some time now, elements of Chinese influence are still present today. For instance, the Iu Mien have maintained a longer written history compared to other nearby ethnic groups. Much of it is based on Chinese characters that have been used to represent Iu Mien words. Today, more than 3,000 Iu Mien reside in Oakland, California, which makes it a center of Iu Mien culture, history, and resources. (Courtesy of Mitchell I. Bonner.)

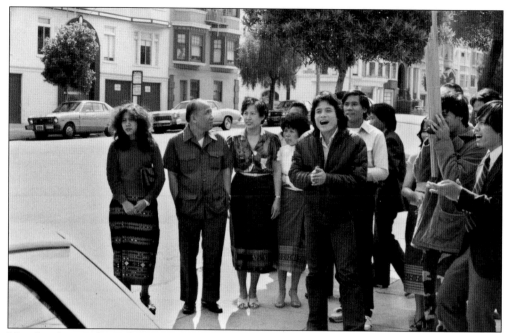

New families are formed in the United States through practicing traditional Lao wedding rituals. In 1981, a group of Laotians prepares to parade the groom through the streets near the bride's house in San Francisco's North of Panhandle neighborhood. Friends and relatives play the *khaen*, sing, march, and announce the arrival of the groom. (Courtesy of Boutsaba Janetvilay.)

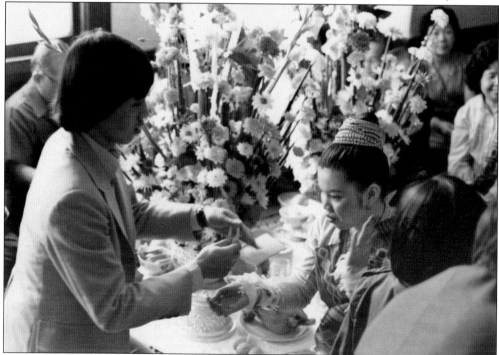

Houmpheng Banouvong is performing a baci ritual to wish his sister Tea Banouvong well on her wedding day in San Francisco in 1981. (Courtesy of Boutsaba Janetvilay.)

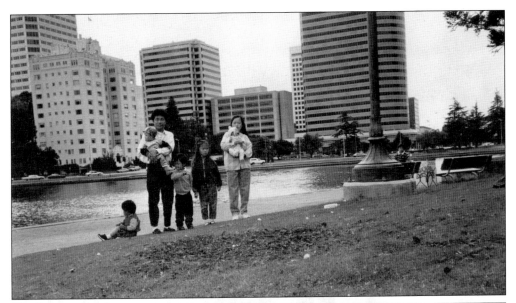

The Iu Mien Saechao family of seven is enjoying the day at Lake Merrit in Oakland, California, in 1993. In the photograph are Yao Saechao (father), Nai Saefong (mother), Mey Saechao (oldest daughter, born in a refugee camp in Thailand), Frank Saechao, Roger Saechao, Chris Saechao, and Sarn Saechao. (Courtesy of Mey Saechao.)

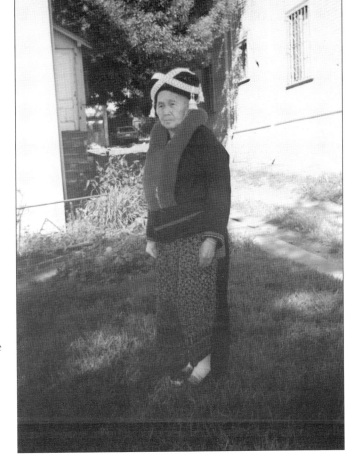

San Francisco State University student Mey Saechao is self-identified as Iu Mien and takes great pride in it. This is a photograph of her great-grandmother Muang Saechao in front of their home in Oakland, California, in traditional Iu Mien clothing in 1990. (Courtesy of Mey Saechao.)

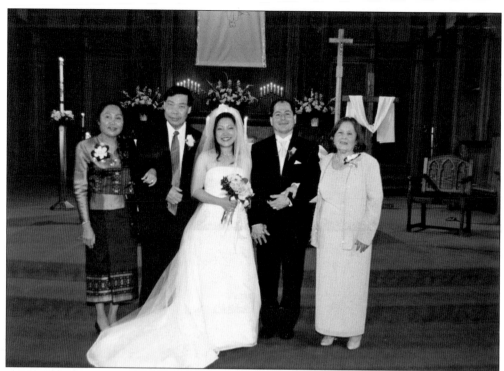

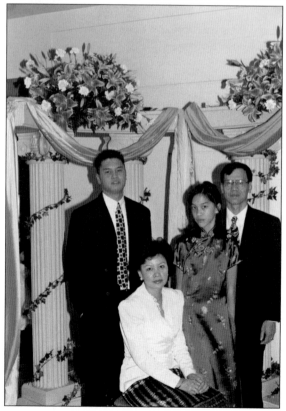

Changing Laotian American families include mixed-raced marriages. Pictured are Darouny Somsanith (bride), Rafael Canela (groom), Bounmy Somsanith (second from left), Vongduane Somsanith (far left), and Leonor Canela, the groom's mother, in Emeryville, California, in 2002. (Courtesy of the Somsanith family.)

Here is a family portrait of the Banouvongs at a relative's Chinese-Lao wedding banquet in San Lorenzo, California, in 2002. From left to right are Ariyakone Banouvong, Kethmani Banouvong, Andrea Banouvong, and Houmpheng Banouvong. (Courtesy of the Banouvong family.)

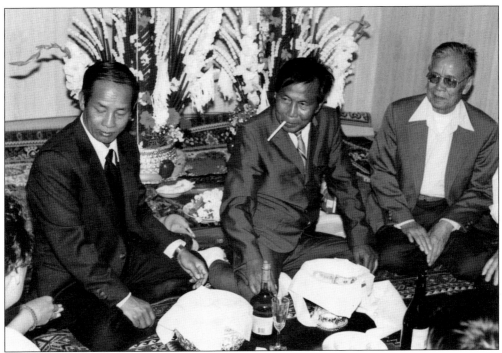

Khamphou Mathavongsy (center), with other Laotian elders, is receiving the dowry from the groom's family the morning before the wedding ceremony in San Pablo, California, in 1991. (Courtesy of Khammany Mathavongsy.)

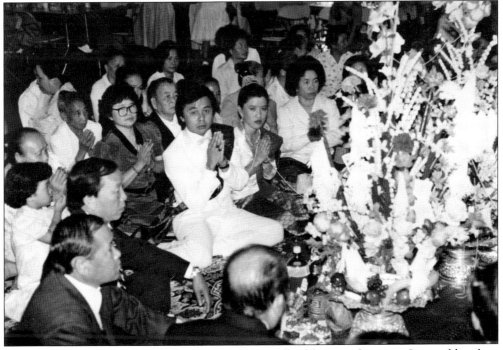

Sean Soungpanya (groom) and Bouakham Sayavong (bride) are performing a Lao wedding baci ritual in Richmond, California, in 1989. (Courtesy of Sean Soungpanya.)

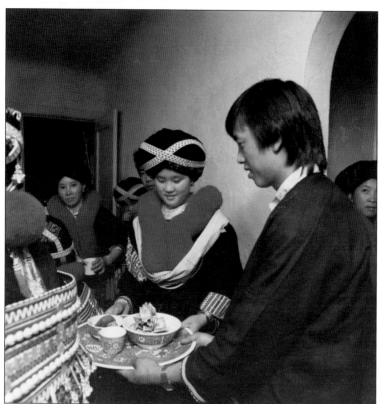

Sou (left) and Nai Saechao (right) receive food and money offerings from guests at their Iu Mien wedding in San Francisco, California, in 1985. (Courtesy of Kouichoy Saechao.)

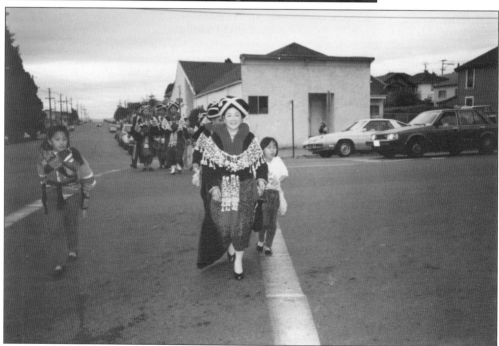

Chaylium Saechao is leading the bride in a procession to the groom's house, where the wedding will take place, in Oakland in 1985. (Courtesy of Kouichoy Saechao.)

# Four

# RELIGIOUS LIFE
# AND RITUALS

Laotian religion is as diverse as the Laotian ethnic groups. The majority of the population is Buddhist, but it is coextensive and ritually integrated with Ph, an indigenous Lao spirit cult. In smaller proportions, Hindu-Brahmanism from India, and Christianity, which is the result of missionary efforts, French colonialism, and informal pressure from Christian refugee relief workers in the refugee camps, are also practiced. Laotian religion, like its Cambodian and Thai neighbors, is a blend of Theravada Buddhism ("the Way of the Elders") and Ph. Laotian Buddhism in the United States has met challenges as Laotian refugees attempt to resettle and adapt to life in the United States while holding on to distinct Laotian culture and values.

At the heart of Laotian Buddhism is the *wat*, a Buddhist temple, which also functions as the main conduit of Lao moral and cultural socialization. In traditional settings, all male Lao are expected to enter monastic life as a monk or novice (*vihan*) prior to marriage. Ordination was a major way to earn merit (*boon*) for oneself, one's parents, and one's village community, as monks become the receivers of alms and merit-making rituals for others and renounce the material world and rely of the generosity of people's donations of food and clothing. Lao women are more active in preparing and presenting offerings of food and clothing to monks, who make their morning alms round through their village carrying an alms bowl. The greatest merit-making ritual revolves around the construction of the Buddhist temple, which minimally must feature living quarters for monks and novices and a main hall where the Buddha statue (*sim*) is housed. As such, Laotian refugee communities throughout the United States, such as in Fort Worth, Texas; Rockford and Springfield, Illinois; Bakersfield, California; Seattle, Washington; Des Moines, Iowa; and Portland, Oregon, as well as in Toronto, Canada; Canberra, Australia; and Paris, France, are preoccupied with the establishment of a Lao Buddhist temple, not only to fulfill their religious needs but also to act as a center for Lao socialization and moral education of young Laotian refugees. Hence, the effort to construct a Lao Buddhist temple is a major component of Lao refugee community stories in the diaspora. Laotian Americans have established their religious communities throughout the Bay Area. For example, the Wat Lao Rattanaram Temple is in Richmond, California, formerly located in West Oakland and founded in 1982; the Lao Lutheran Church, the Khmu and Iu Mien Baptist Church, and the Khmu Catholic Church are also located in Richmond; the Khmu Mormon Church is in El Sobrante, California.

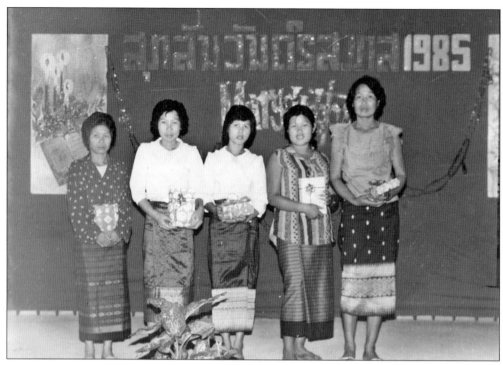

ສະຫລອງວັນຄຣິສມາສ 1985

Laotian Christian converts at the Lao
Christian Evangelical Church are
exchanging gifts during Christmas
in the Napho Refugee Camp in
Thailand in 1985. (Courtesy of
Khammany Mathavongsy.)

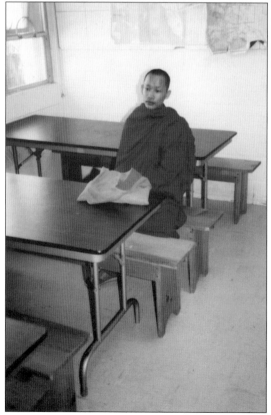

A refugee Laotian Buddhist monk
is in a classroom at Hamilton Fields
resettlement processing center in
1981. His presence within the Laotian
Buddhist community is central, as he
will be called upon to perform rituals
and transmit Buddhist teachings
to members of the community.
(Courtesy of Mitchell I. Bonner.)

In 1982, Laotian children are participating in church-sponsored programs during the summer in San Francisco. From left to right are Olay Nhonthachit, an unidentified church member, Naly Nhonthachit, and Pinmany Janetvilay. (Courtesy of Boutsaba Janetvilay.)

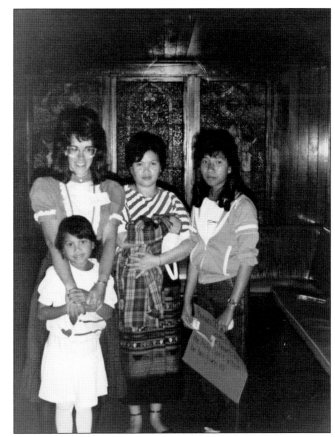

Laotian Buddhists lay shawls down for monks to walk on at a Buddhist ceremony at Wat Lao Rattanaram in West Oakland, California, in 1991. As the first Lao Buddhist temple in the San Francisco Bay Area, Wat Lao Rattanaram is an important resource for the Lao Buddhist community. (Courtesy of Boutsaba Janetvilay.)

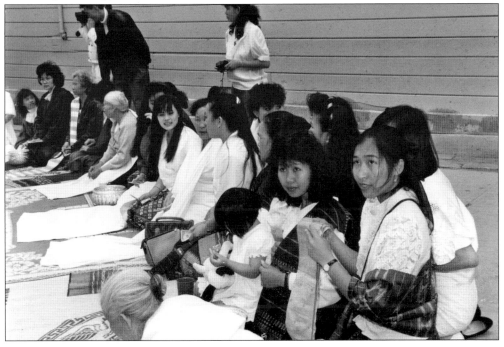

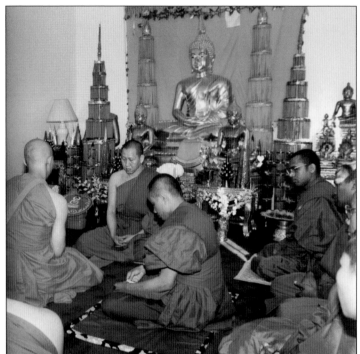

Pictured in 1991 is an ordination ceremony of Laotian Buddhist monk at Wat Lao Rattanaram in West Oakland. Lao Buddhist Americans continue the tradition of Buddhist ordination before marriage as a means to earn merit for their parents and for their community. Buddhist values, mores, and ethics are learned, and Buddhist traditions are transmitted. The length of time that they live as ordained monks is shortened from several months to several weeks. (Courtesy of Boutsaba Janetvilay.)

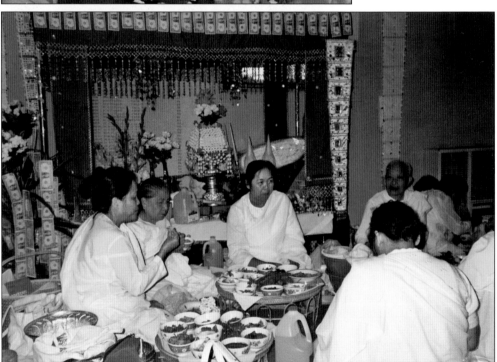

Group of Laotian lay elder Buddhist women spends the weekend at the Wat Lao Rattanaram in 1987. They are observing and refraining from the following eight Buddhist precepts: killing, stealing, sexual activity, lying, alcohol and drugs, eating after 12:00 p.m., entertainment, and sleeping on a soft bed. (Courtesy of Chanthanom Ounkeo.)

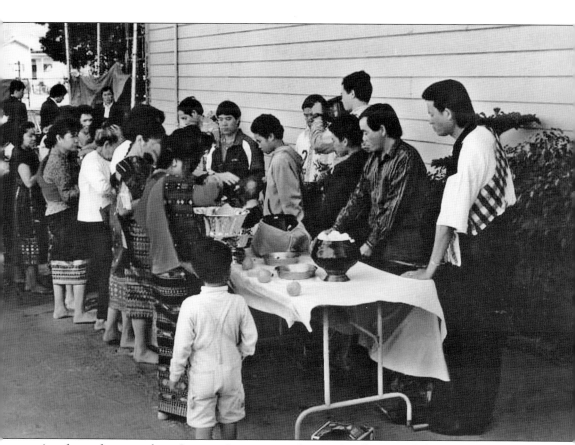

As a form of merit-making, Laotian Americans make temple offerings to help support the monks at Wat Lao Rattanaram in 1980. (Courtesy of Mitchell I. Bonner.)

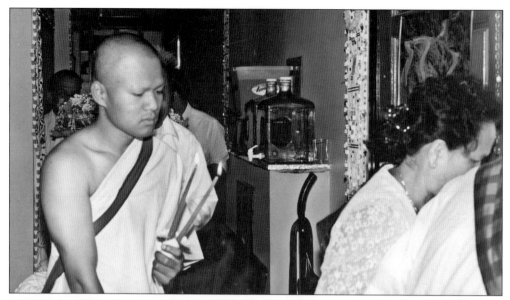

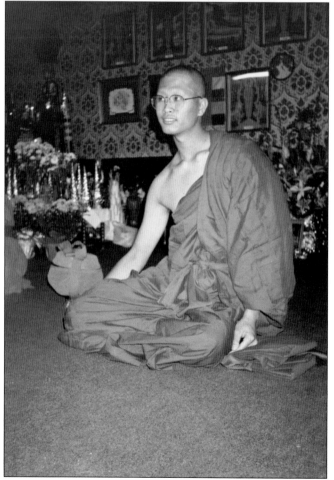

As a rite of passage, all Laotian Buddhist males must be ordained as a monk. This act brings blessings to their families as well as teaches them Buddhist morals, ethics, and values. This tradition continues in the United States. Here, Khammany Mathavongsy undertakes the Buddhist ordination ritual at Wat Lao Rattanaram in West Oakland in 1991. (Courtesy of Khammany Mathavongsy.)

Vinya Sysamouth, executive director of the Center for Lao Studies, is being ordained as a full monk in 1992. Traditionally, Laotian Buddhist men will spend three months in the wat during the Buddhist Lent between June to September; however, in the United States, it ranges from two weeks to the full three months. (Courtesy of Vinya Sysamouth.)

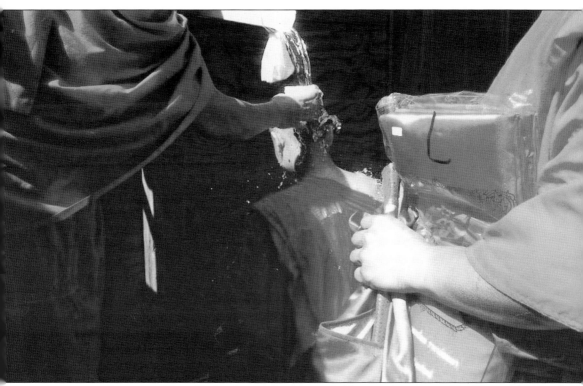

A water purification, or Kong Hod in Lao, is a ceremonial ablution of a respected Buddhist monk. Water is poured over the monk in the temporary wooden cell, first by venerable senior monks and then followed by lay Buddhists. This ceremony is being performed here in Wat Lao Rattanaram in 2011. (Courtesy of Wat Lao Rattanaram Temple.)

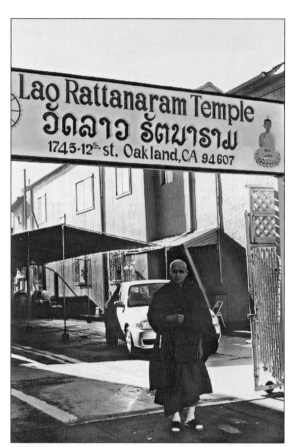

A Laotian monk is in front of Wat Lao Rattanaram. Wat Lao Rattanaram was founded in 1982 to provide the spiritual needs of the growing Laotian American population. (Courtesy of Wat Lao Rattanaram Temple.)

Wat Lao Rattanaram relocated to Richmond, California, in 2003. It is one of the main sites for community events, such as the celebration of Lao New Year. Previously, the temple was a Christian church. The exterior of the building still looks like a Christian church, while the interior has been transformed into a Lao Buddhist sacred site. The community chose the current site because it is centrally located across from Richmond Civic Center and is zoned as a religious institution. (Courtesy of Wat Lao Rattanaram Temple.)

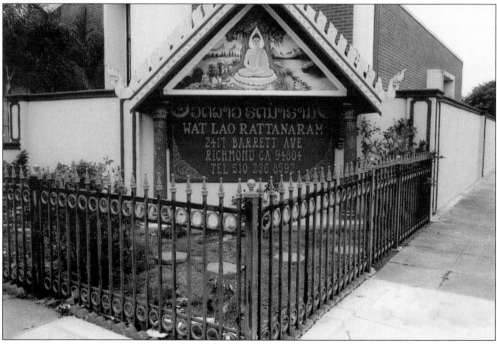

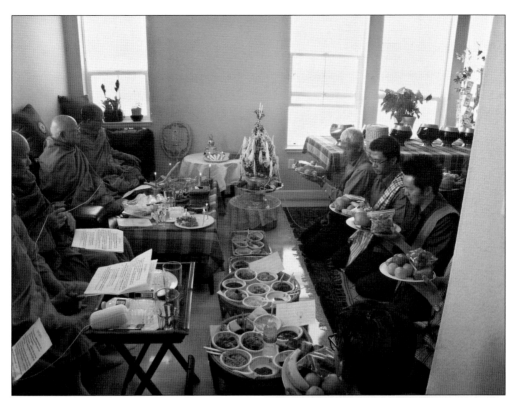

Buddhist monks from the Wat Lao Rattanaram perform a housewarming ceremony at the home of Vinya Sysamouth (right side, wearing checkered sash) and Thang Nguyen (right of Vinya) in South San Francisco in 2010. It is customary for the Buddhist Lao to have monks bless and purify the home in order to bring good luck, health, and prosperity to the dwellers. (Courtesy of Wat Lao Rattanaram Temple.)

An Iu Mien shaman is dressed in traditional clothing in Oakland, California, in 1985. The Iu Mien religion combines animism and Chinese Daoism. A shaman's role is significant in the Iu Mien community. He is considered a community leader who has spiritual knowledge that people rely on to solve problems they may encounter, such as illness, disharmony in the family, and so on. Thus, members of the community look to him to prescribe the proper ceremony to address the situation, which he does by diagnosing the spiritual cause of the problem and by consulting the astrological calendars for an auspicious date to hold the ceremony. (Courtesy of Mey Saechao.)

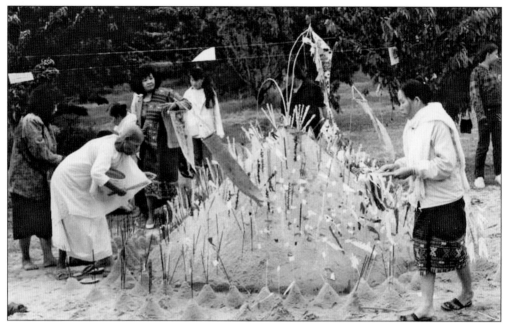

Laotian Buddhists build a sand stupa decorated with incense, prayer flags, and flowers to be donated to the temple after the ceremony in Oakland, California, in 1980. (Courtesy of Mitchell I. Bonner.)

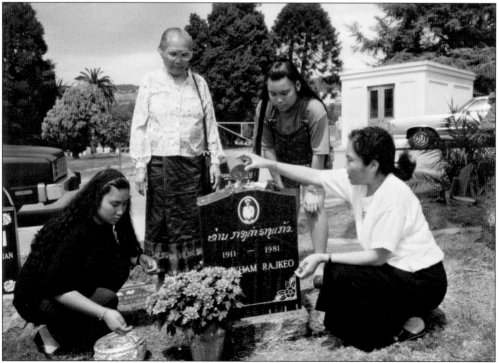

As a way to memorialize life, Laotian Americans visit their ancestors during Lao New Year by sharing family stories and maintaining familial bonds. Here, family members visit the headstone of Kongkham Rajkeo in Oakland, California, in 1982. (Courtesy of the Somsanith family.)

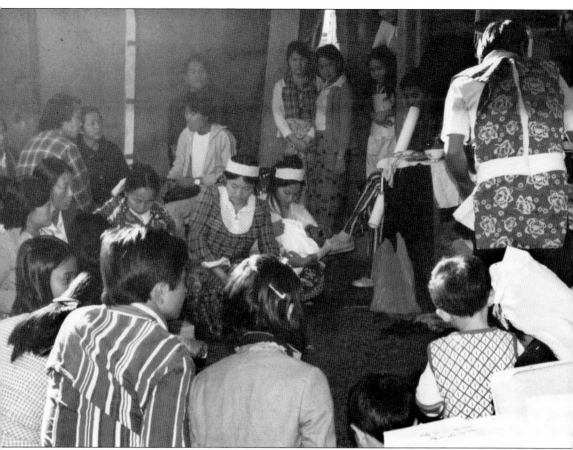

This Iu Mien funeral took place in Oakland, California, on October 30, 1981. According to Iu Mien traditions, the death of a family member requires carrying out a very specific set of rituals. If a parent has died, for example, the first son would have to help shut the eyelids and insert a silver coin in the corpse's mouth. It is believed that when a person dies with his/her eyes open, it means he/she died unhappily. Therefore, by closing the eyelids of a corpse, the living person says, "Please go happy, leave any regrets behind." At the same time, in accord with Iu Mien traditions, a shaman who understands the complex astrological calendars will be consulted to determine an auspicious date to hold the funeral ceremony. This ensures that the recently deceased is comfortable in his/her transition to the spirit world. (Courtesy of Kouichoy Saechao.)

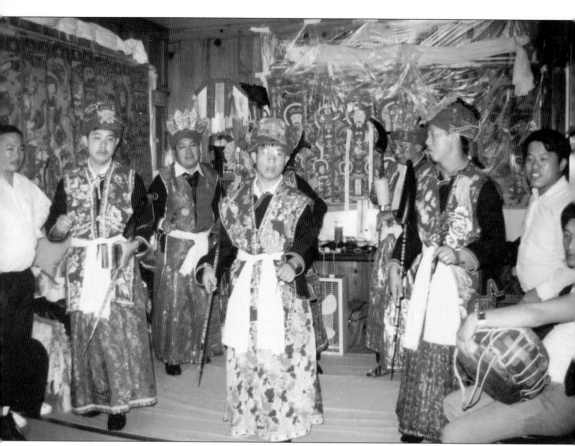

A rite of passage to become a Daoist priest, the Iu Mien Kuatang ceremony is performed at Kouichoy Saechao's house in Oakland in 1991. It is a three-day ceremony that involves the entire community. Members participating in the ceremony must take a vow of vegetarianism to remain pure for three days. (Courtesy of Kouichoy Saechao.)

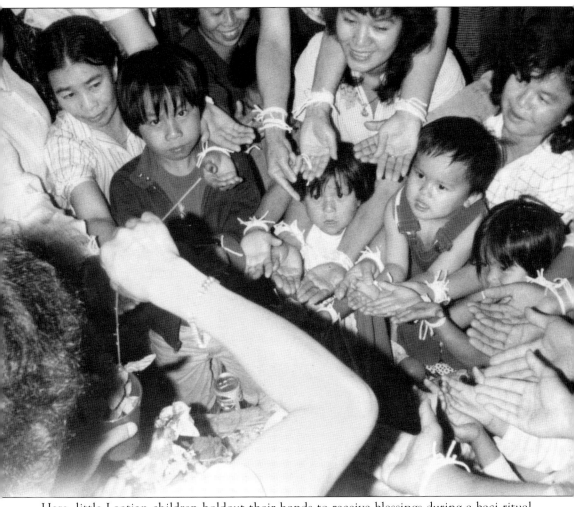

Here, little Laotian children holdout their hands to receive blessings during a baci ritual, performed at Ray Soungpanya's house in Richmond, California, in the early 1980s. (Courtesy of the Soungpanya family.)

Here is an icon of King Pan at the Lao Iu Mien Culture Association (LIMCA), Inc., in Oakland. LIMCA was founded in 1982 to preserve the culture and heritage of the Iu Mien who came from the highland Lao tribal community. In November 1996, LIMCA purchased a property at 485 105th Avenue in Oakland, California, to establish an Iu Mien Cultural Center that would include a King Pan Temple (King Pan Buddha Light Palace) and a community center. The building was to be used to operate program activities, meetings, weddings, ESL/Iu Mien language instruction, elderly and youth activities, a Iu Mien library/museum, economic development, and a health care education center. (Courtesy of Kouichoy Saechao.)

# Five

# FESTIVALS AND CELEBRATIONS

In the United States, many traditional holidays are observed; however, they are altered because of scheduling and time conflicts and constraints. Traditional agricultural rituals performed in conjunction with merit-making rituals at the Lao temple have been changed to meet the demands of American life. Calendar-based village festivals, such as the Bun Bang Fai (rocket festival), or rituals associated with the monastic communities, like ordination and merit-making, have an opportunistic bent, as Lao monks may only visit a Lao community occasionally. Thus, Laotian Americans have to take advantage of the opportunities to perform religious rituals and receive dharma lessons when a monk is available; this is especially true for small communities where a Lao temple has not yet been established. In the United States, Laotian elders have had to assume the responsibilities of religious specialists in the absence of monks. American foods, like Coca-Cola, have been adapted in Lao offerings, and audiotaped recordings of sermons by monks have been used as substitutes for real monks during ritual occasions. A Lao Buddhist temple is an important site for cultural preservation among the first-generation Lao Americans who grow up speaking English. Hence, bilingual monks are in high demand.

The majority of Laotian American festivals and holidays are religious celebrations. The Lao word for festival is *boon*, which means "merit" or "good deeds." Laotian festivals and holidays are based on the lunar calendar, in particular the Buddhist calendar. Laotian festivals are typically held at Buddhist temples, which is why it is very important for Laotian American communities to build temples in their communities. Buddhist festivals are popular among Laotian Americans, because over 85 percent of Laotian Americans are Theravada Buddhist.

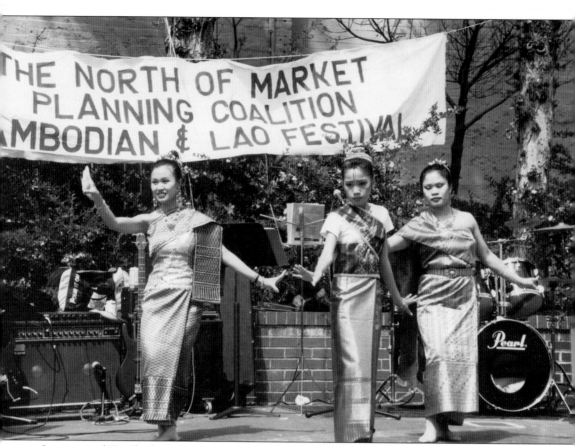

Laotian and Cambodian Americans are celebrating a pan–Southeast Asian community New Year festival in San Francisco's Tenderloin neighborhood with the North of Market Planning Coalition in April 1984. (Courtesy of Chanthanom Ounkeo.)

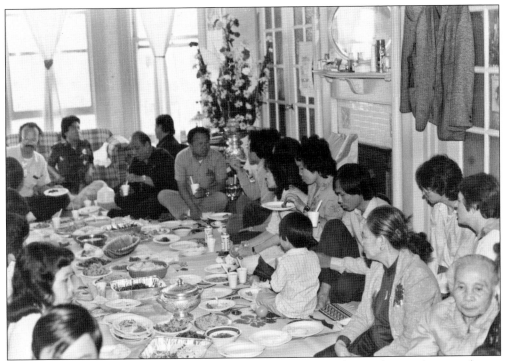

In San Francisco, California, in 1983, Laotian friends and family members gather together to perform a blessing ritual for a newborn baby. The bouquet of flowers in the background indicates that a baci ceremony has been carried out. (Courtesy of Boutsaba Janetvilay.)

In 1982, Chirasak Janetvilay is seen at his first birthday celebration in the United States with relatives. From left to right are (first row) Ariyakone Banouvong, Susy Nhonthachit, Chirasak Janetvilay, Ai Nhonthachit, and Noy Nhonthachit; (second row) Boutsaba Janetvilay, Pinmany Janetvilay, Teng Banouvong, Ketsomchay Soumpholphakdy, Sarathy Janetvilay, and Loy Soumpholphakdy. (Courtesy of Boutsaba Janetvilay.)

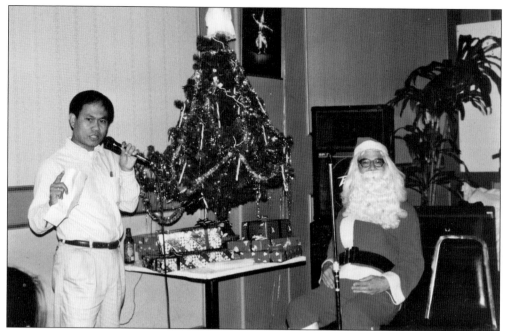

Bounchanh Thepkaysone and Mitchell Bonner (in the Santa Claus costume) hand out gifts to Lao children in San Francisco at a 1986 Lao Seri Christmas party. It was not long after Lao refugees arrived in the United States that their children learned about Christmas and the traditions attached to the holiday. Although most Lao refugees were Buddhists or animists, they learned to accommodate Western holiday traditions into their daily lives, such as birthday parties, Thanksgiving, and Christmas. (Courtesy of Bounchanh Thepkaysone.)

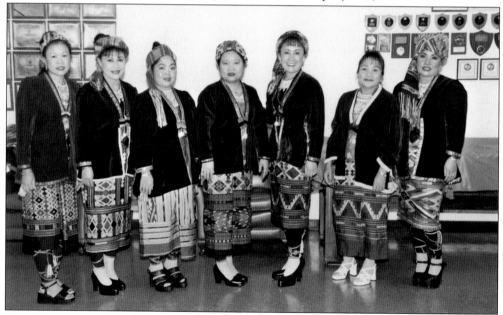

Here, Khmu women are dressed for the Khmu New Year celebration in Richmond, California, in 2004. Lao New Year is typically celebrated during the month of April, while the Khmu celebrate their New Year in December. (Courtesy of the Keosaeng family.)

A Khmu New Year festival is hosted at the Veteran's Memorial Hall in Richmond in 1995. (Courtesy of the Keosaeng family.)

The Khmu community welcomes the last surviving royal prince, Souriyavong Savang, and his family from France by offering rice wine at the Maple Hall at San Pablo City Hall in 1999. (Courtesy of the Keosaeng family.)

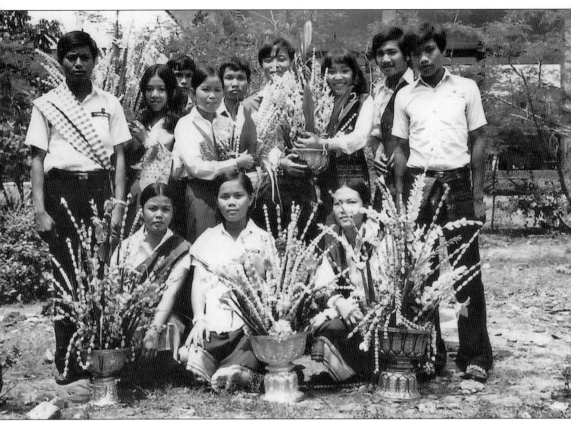

In 1972, Bouavanh Syphandone Sydavong (standing third from right) and her classmates from the Ecole Normal Savannakhet prepare to pay respect and honor to their teachers by presenting them with traditional Lao floral arrangements during the annual National Teacher's Day celebration. (Courtesy of Bouavanh Syphandone Sydavong.)

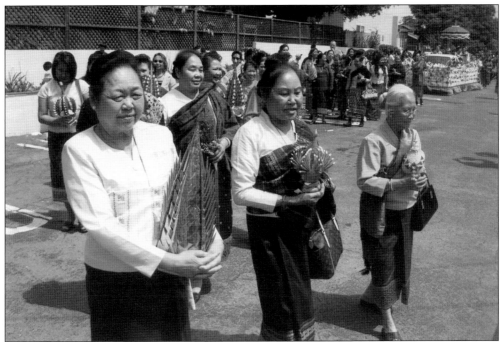

Here is a Nang Sang Kan procession during the Lao New Year celebration at Wat Lao Rattanaram in 2003. (Courtesy of the Somsanith family.)

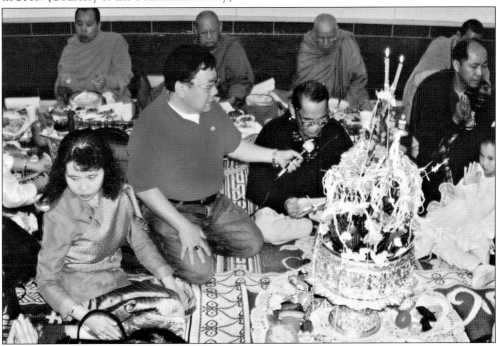

Laotian Americans continue to celebrate many Laotian customs, festivals, and holidays in America according to the Theravada Buddhist calendar. Chief among them is the Lao New Year (Boon Pii Mai). Here, it is being celebrated in San Francisco's YMCA in 1985. (Courtesy of Chanthanom Ounkeo.)

Here, current California state senator Leland Yee congratulates the Laotian American community on its civic achievement. (Courtesy of the Center for Lao Studies.)

The annual International Lao New Year festival has been held at the San Francisco Civic Center or the United Nations Plaza at the end of April of each year since 2009. The festival, cosponsored by Center for Lao Studies (CLS) with the Laotian American National Alliance (LANA) and the Lao Heritage Foundation (LHF), has participants from around the world. (Courtesy of the Center for Lao Studies.)

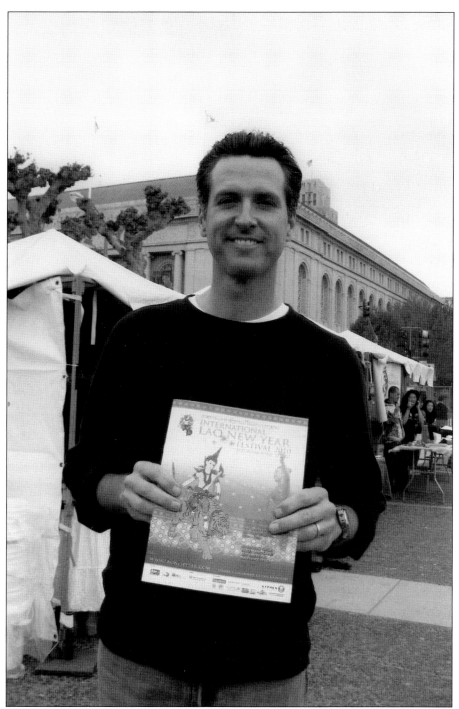

The 42nd mayor of San Francisco, Gavin Newsome, attended the second International Lao New Year Festival (ILNYF) in San Francisco in 2010. Hosted by the Center for Lao Studies, Lao Heritage Foundation, and the Laotian American National Alliance, the ILNYF is the largest Lao New Year festival in the United States, attracting more than 10,000 attendees each year. (Courtesy of the Center for Lao Studies.)

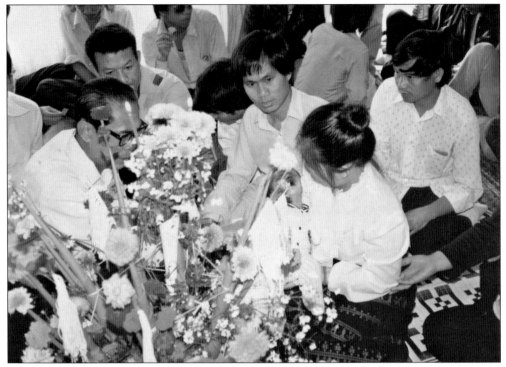

Here is a baci ceremony for Bounchanh Thepkaysone's first son, Bailey, on August 1981. Today, Bailey is a police officer in El Cerrito, California. (Courtesy of Bounchanh Thepkaysone.)

In Oakland, California, in 1989, two Iu Mien children are dressed in new clothes to celebrate Iu Mien New Year. They are Mey Saechao (left) and Pao Saefong. (Courtesy of Mey Saechao.)

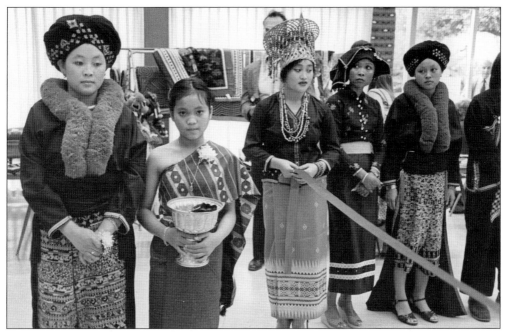

Here is a Laotian embroidery exhibition in San Francisco's Tenderloin neighbor in 1981. The Iu Mien are known for their embroidering. Knowing how to hand embroider is regarded as a very important skill for young Iu Mien women to learn. Embroideries can have different meanings and can tell different stories that relate to history and culture. (Courtesy of Kouichoy Saechao.)

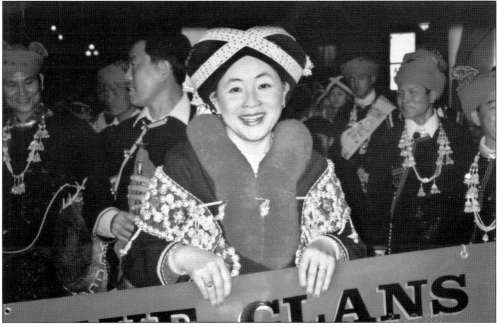

Representing the Iu Mien 12 clans, Chaylium Saechao is at the San Francisco Chinese New Year Parade in the early 1990s. The 12 clans originate from Iu Mien folklore, where King Pan, the forefather of the Iu Mien people, designated each one of his 12 children, six sons and six daughters, with 12 clans and surnames. (Courtesy of Kouichoy Saechao.)

The Iu Mien 12 clans are participating in the Oakland Chinese New Year Parade in the early 1990s. (Courtesy of Kouichoy Saechao.)

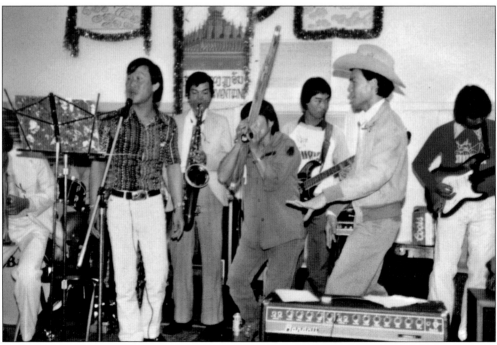

Here is a Lao New Year celebration in San Rafael, California, in 1981. (Courtesy of Mitchell I. Bonner.)

# Six

# COMMUNITY
# ORGANIZATIONS AND
# ASSOCIATIONS

There are several community organizations and associations dedicated to ensuring the health and wellness of the Laotian American communities, such as the Lao Seri Association of San Francisco; the Lao Association of the Bay Area, founded in 1989; the Khmu Association of the Bay Area; the Lao Art and Culture Association of Oakland, California; and the Lao Lan Xang Association, founded in 1981. And there are several nonprofit organizations, like Lao Family Community Development in Oakland and San Pablo, California; the Center for Lao Studies (CLS) in San Francisco; Nhat Mith Association; and the Lao Women's Association of the Bay Area. These community organizations and associations reflect the diversity among the Laotian American communities.

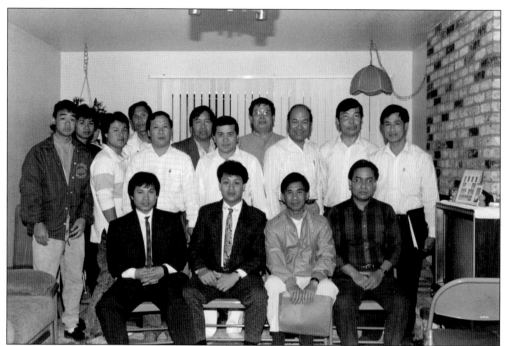

Here is the Lao Lan Xang Association's first meeting in San Francisco in 1983. Lao Lan Xang is one of the first community mutual assistance associations created to provide resettlement services to newly arrived Laotian refugees. (Courtesy of the Somsanith family.)

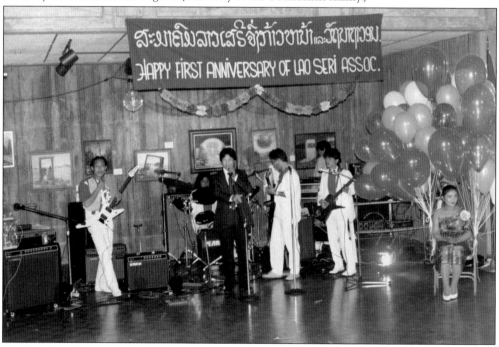

The Lao Seri Association's second anniversary in 1987 included a soccer tournament and beauty pageant. Bounnhock Nhouthitham was the emcee for the night. (Courtesy of Bounchanh Thepkaysone and the Lao Seri Association.)

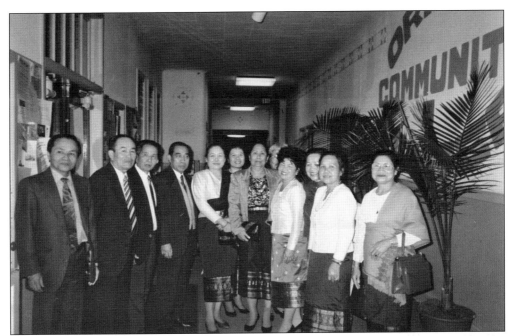

The Lao Women's Association of the Bay Area's fundraiser in 1994 was hosted at the Orinda Community Center. From left to right are Ken Thirakul, Somphoang ?, Thongthip ?, Khamouane ?, Bounsouei Sphabmixay, unidentified, Phet Luangrath, Khamphoy Damrong, Kongkeo ?, Kesa Thirakul, and unidentified. (Courtesy of the Somsanith family.)

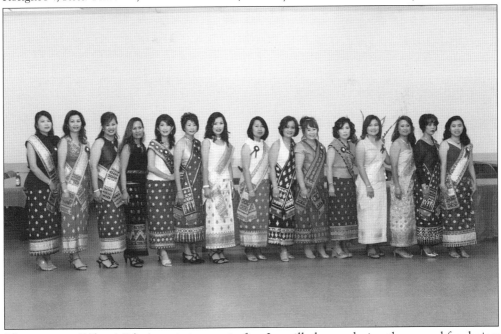

The women of Nhat Mith Association are in fine Lao silk dresses during the annual fundraiser in Richmond, California, in 2003. From left to right are Noi ?, Phanousone ?, Mia ?, unidentified, Southichanh ?, Phongsi ?, Nang ?, Khanthaly ?, Doung ?, Boualoi ?, Khamphoua ?, Kinnaly ?, Bai ?, Sidachanh ?, and Sonthida ?. (Courtesy of the Sackdavong family.)

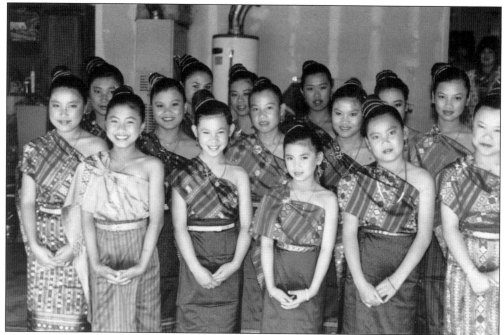

One of the primary missions of the Lao Women's Association of the Bay Area is to pass on Lao cultural heritage to the young Lao-born American youths. In 1989, young Lao girls are seen in silk dresses with traditional hairdos during a Lao dance performance practice in a garage in San Pablo, California. (Courtesy of the Somsanith family.)

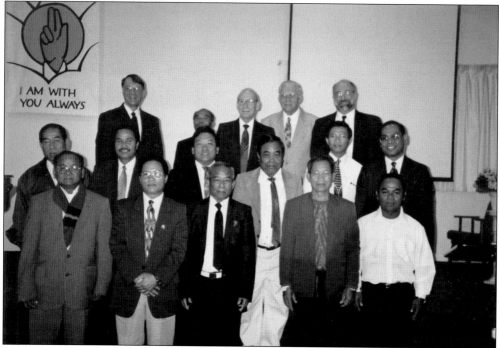

Here is the ordination of Khmu Baptist Church pastors who served the Richmond congregations in 2000. (Courtesy of the Keosaeng family.)

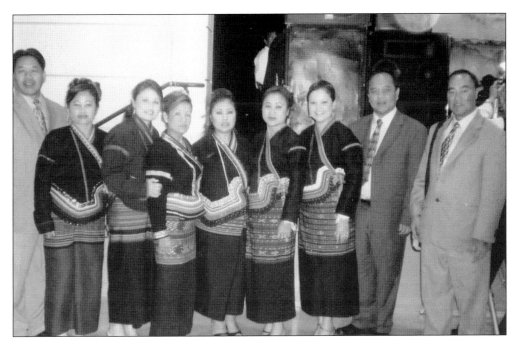

Here is the 2003 fundraiser of the Khmu Women's Association in Richmond. From left to right are Torm Nomprasert, Air Darasaeng, Kerry Manivanh, Nang Keosaeng, Sy Keomanivanh, Khamonh Boonkert, Chanh Saengsourith, Manh Phongboupha, and Chris K. Karnsouvong. (Courtesy of the Keosaeng family.)

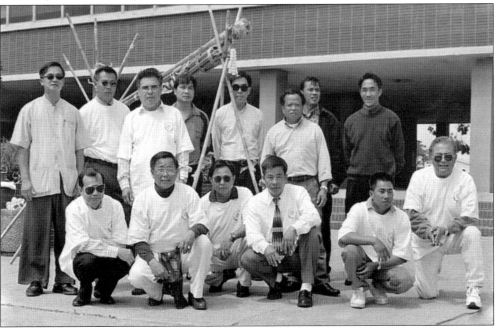

Members of the Sumphun Phinong Lao Association pose in front of Richmond City Hall in 1999. The bamboo object is a replica of a rocket that is used in rocket festivals back in Laos. During a rocket festival, the homemade rockets are shot into the sky to ask the gods for rain during the planting season. (Courtesy of Sumphun Phinong Lao Association.)

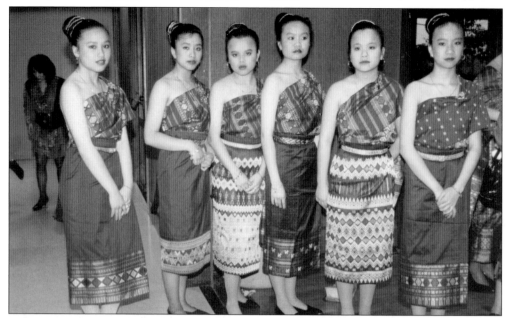

The young dancers of the Sumphun Phinong Lao Association dress in traditional Lao outfits made of pure silk in 1995. (Courtesy of Sumphun Phinong Lao Association.)

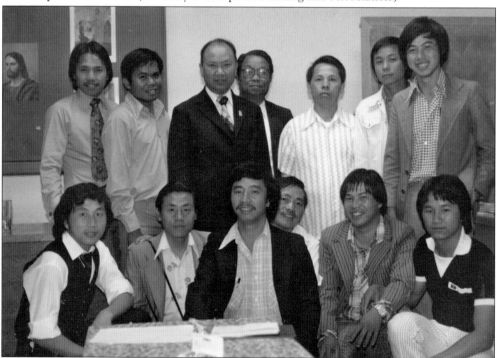

Vang Pao paid a visit to Lao Family Community Development, Inc., in the early 1980s. Vang Va was the president at the time. From left to right are (first row) Wenphou Phan, Chanchien Chao, Vang Va, Chaosarn Saechao, Dr. Vang Ser, and Vang Ying; (second row) Kouichoy Saechao, Ray Soungpanya, Vang Yee, unidentified, Vang Pao, Preekert ?, and Torm Normprasert. (Courtesy of Kouichoy Saechao.)

The first Iu Mien New Year celebration at the Women's Building in San Francisco took place in February 1981. Kouichoy Saechao was the main organizer with help from members of the Lao Iu Mien Culture Association. (Courtesy of Kouichoy Saechao.)

# CENTER FOR LAO STUDIES

The mission of the Center for Lao Studies is to advance knowledge and engagement in the field of Lao Studies through research, education, and information sharing. The vision of the CLS is to be an institution that leads and excels in the pursuit of knowledge in the field of Lao studies. The CLS's main programs include the International Conference on Lao Studies, the Journal of Lao Studies, the Summer Study Abroad in Laos, and the Lao Oral History Archive. (Courtesy of the Center for Lao Studies.)

# Seven

# YOUTHS AND RECREATION

Laotian American youths adapted to life in the United States and maintained a bicultural sensibility. Many spoke their native language at home while they engaged in English in school and outside of their homes. Their parents instilled in them pride for their culture and heritage. Similar to other Asian American youths, Laotian American youths feel the pull of two cultures, which makes growing up American a unique experience. For instance, Laotian American youths are taught to be individualistic and to speak their minds in school. The ethos of individualism is expressed in their questioning of authority figures, which includes their parents, as well as their thinking of themselves as unique individuals. In addition, the pressures to assimilate and to be an American influence their lives in such ways as wearing hip and cool clothing, listening to hip-hop music, and speaking English to dating, eating American foods like hamburgers and pizza, and so on. On the other hand, at home, their parents expect them to act and be Laotian. The focus is not on individuality but on collective responsibility and identity. Rebelling against authority is seen as misbehavior. This cultural conflict between first-generation refugee parents and second-generation Laotian American youths is strong and real. Out of this cultural conflict, Laotian American youths in the San Francisco Bay Area have grown up with an appreciation for both cultures. They celebrate their Laotian heritage and take great pride in their Laotian ethnic lifeways and cultural traditions. Having a vibrant network of Laotian American community centers, organizations, and associations that serve as repositories of Laotian heritage, culture, and language is central to the production of Laotian American youths who are bicultural, bilingual, and committed to their communities.

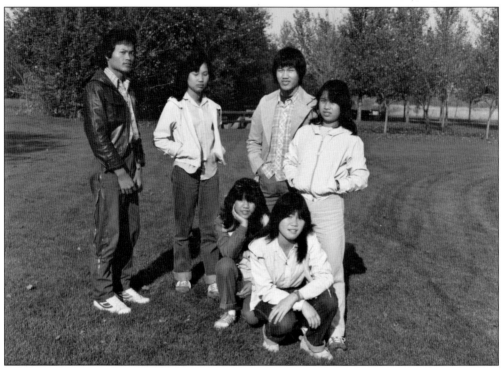

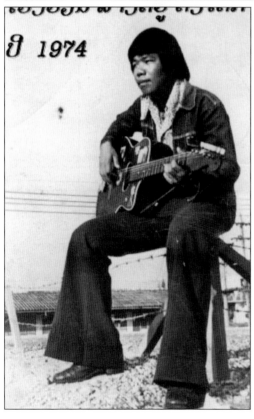

A group of Laotian teens is at a park in Vancouver, Washington, in 1985. They had all resettled in the San Francisco Bay Area by the late 1980s as a result of the secondary migration process. From left to right are (standing) Singh Yanouphet, Pam Somphone, Pam Sayavong, and Seng Manixay; (kneeling) Bouakham Sayavong and Thongchan Sipanya. (Courtesy of Bouakham Sayavong.)

Saysombath Houngviengkham is playing the guitar at Dong Dok Normal Teacher College in Laos in 1974. (Courtesy of Saysombath Houngviengkham.)

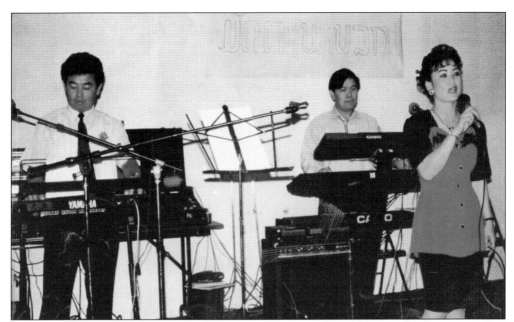

Muang Neua band members include Oradee Houngviengkham (singer), Singkham Houngviengkham (keyboard, left), and Saysombath Houngviengkham (keyboard, right); they are performing at the annual Mitraphab Houaphan Association fundraiser in 1995. (Courtesy of Saysombath Houngviengkham.)

At the Henry Kaiser Center in Oakland, California, in 1981, Saysombath Houngviengkham is playing Lao folk music on a *khene*, a mouth organ that creates a sound similar to that of the violin. This instrument is usually made of bamboo. (Courtesy of Saysombath Houngviengkham.)

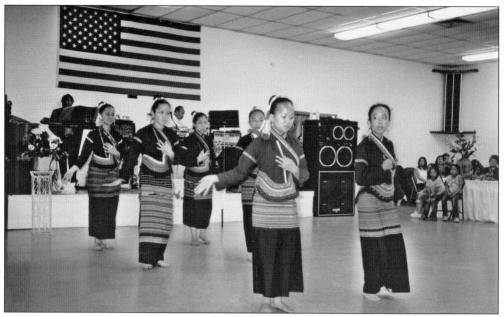

Khmu teens are dancing at the annual Khmu New Year celebration in Richmond, California, in 2004. From left to right are Sengthip ?, Amy ?, Chom ?, Sandy ?, Sandra ?, and Tina ?. (Courtesy of Chris Khamvong Karnsouvong.)

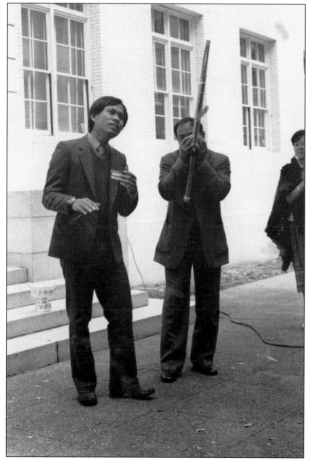

Bounchanh Thepkaysone (singer) and Boongeun Sirivath (khene player) demonstrate traditional singing that involves storytelling at the United Nations Plaza in San Francisco in May 1986. (Courtesy of Bounchanh Thepkaysone.)

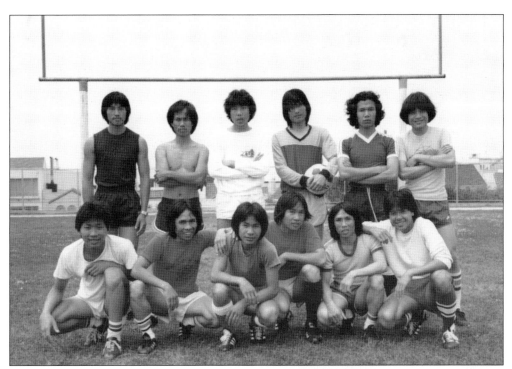

A Laotian soccer team is participating in a tournament held at Washington High School in San Francisco in July 1982. The San Francisco Lao soccer team was in the B League and competed against other Asian/Pacific Islander teams. Members are, from left to right, (first row) Manh ?, Thaophouth ?, Thaopheng ?, Thaophan ?, and two unidentified; (second row) unidentified, Bounchanh Thepkaysone, unidentified, Khammai Vongsy, Khamsamone Oriyavong, and Bounthieng Thepkaysone. (Courtesy of Bounchanh Thepkaysone.)

A transgender Lao woman is at a house partying in San Francisco in 1980. (Courtesy of Mitchell I. Bonner.)

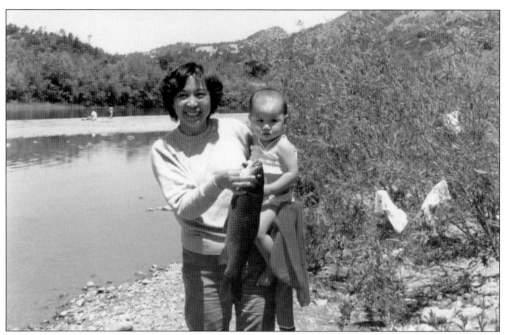

Sousiva Janetvilay and Angelina Galang (the child) are showing off their prize catch of the day in 1982. Even though Sousiva lived in the city, she enjoyed fishing in the Russian River in Santa Rosa. (Courtesy of Boutsaba Janetvilay.)

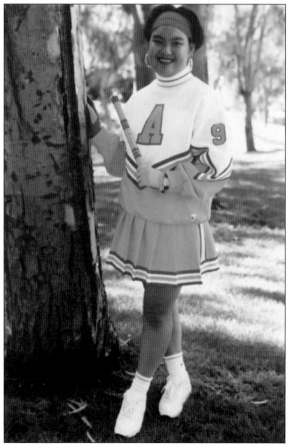

Second-generation Laotian American teen Phammaly Somsanith participates in the De Anza High School cheerleading squad in Richmond, California, in 1996. (Courtesy of Bounmy Somsanith.)

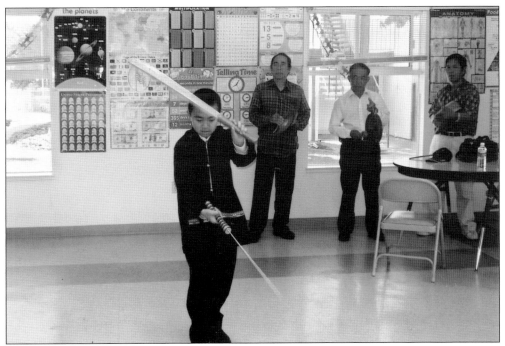

Here, a Lao Khmu boy performs a folk sword dance in Richmond, California, in 2003. (Courtesy of Chris Khamvong Karnsouvong.)

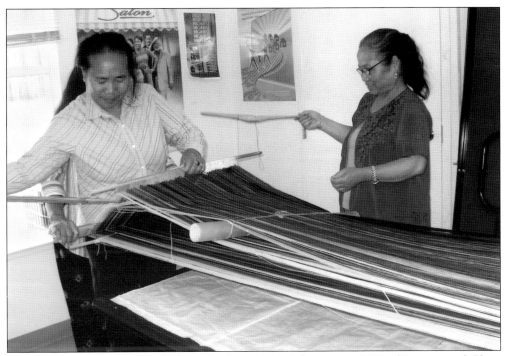

Lao Khmu women weave cloth in Richmond, California, in 2003. (Courtesy of Chris Khamvong Karnsouvong.)

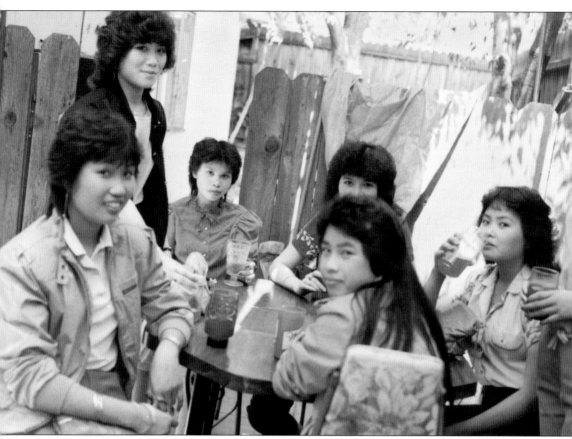

In 1985, Laotian teens gather in a backyard in Richmond, California; they are, from left to right, Pam Somphone, Thongchan Sipanya, Chom Inthavong, Sengpha Sipanya, Sa Yanouphet, and Seng Manixay. (Courtesy of Phoumy Sayavong.)

# *Eight*

# CIVIC ENGAGEMENT

The Laotian American communities of the San Francisco Bay Area have been civically engaged in social justice movements and have taken their civic duties seriously. Although there is a split between the older first generation, who tend to be more conservative, and the second generation, who tend to be more progressive, both groups collaborate in efforts to increase Laotian American visibility. The Laotian American National Alliance sponsored the 2010 Census campaign "Be Proud to Be Laotian: Your Count Is Our Future, Write Laotian." Here, second-generation Laotian Americans mobilize grassroots community organizing to assist their elders write-in Laotian. This will make it possible for Laotian American communities to get much-needed resources in the future to meet the needs and challenges of their communities. Chief among them is post-traumatic stress disorder for immigrant refugees.

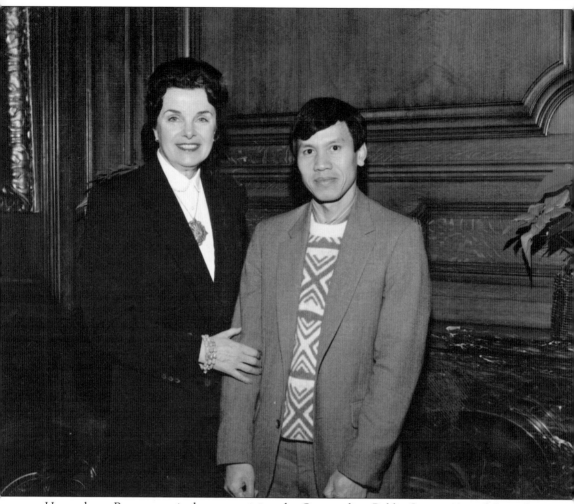

Houmpheng Banouvong is shown receiving the Outstanding Public Service Award from the 38th mayor of San Francisco, Dianne Feinstein, at San Francisco City Hall in 1988. Feinstein is the senior US senator from California. She has served in the Senate as a Democrat since 1992. (Courtesy of Houmpheng Banouvong.)

Here, Kouichoy Saechao lectures at a cross-cultural awareness conference in Fresno in 1986. (Courtesy of Kouichoy Saechao.)

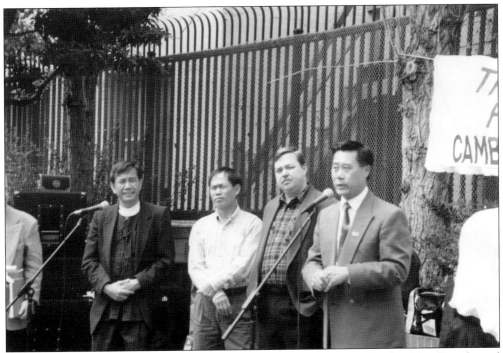

Current California state senator Leland Yee speaks at the Lao and Cambodian New Year festival in San Francisco's Tenderloin neighborhood with the North of Market Planning Coalition in 1984. (Courtesy of Chanthanom Ounkeo.)

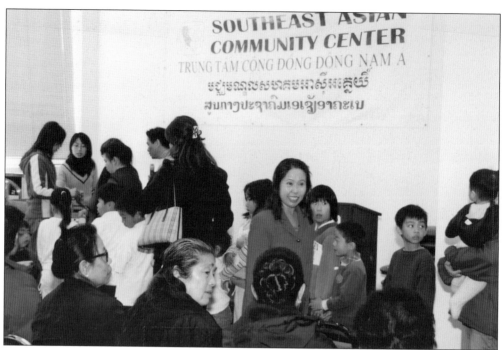

Here is a Lao community meeting at the Southeast Asian Community Center in San Francisco's Tenderloin neighborhood in 1988. (Courtesy of Chanthanom Ounkeo.)

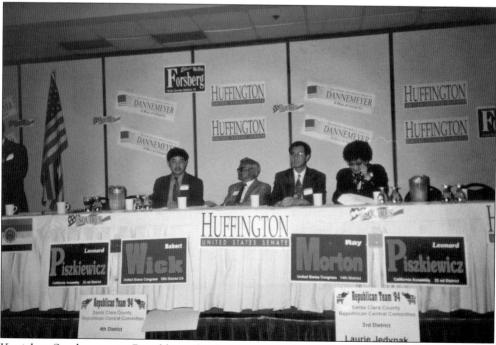

Kouichoy Saechao is at a Republican fundraising event during the midterm election of 1994 in Foster City. (Courtesy of Kouichoy Saechao.)

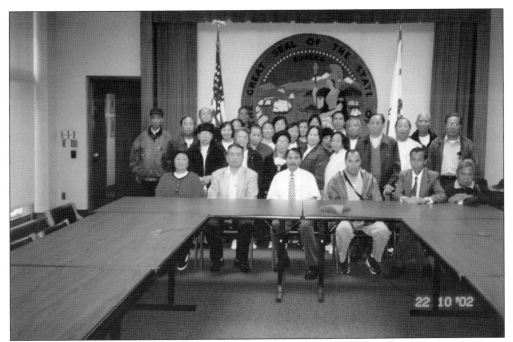

In Sacramento in October 2002, The Lao Senior Association of the Bay Area and its members at are pictured in Gov. Gray Davis's press office protesting cuts to Medi-Cal. (Courtesy of Chris Khamvong Karnsouvong.)

This crime prevention project included a community block party in San Pablo, California, in 1997. (Courtesy of Chris Khamvong Karnsouvong.)

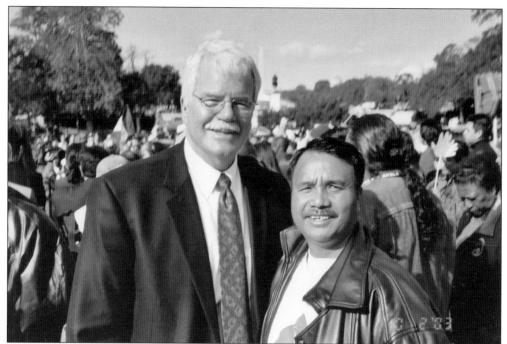

In 2003, Pastor Khamsaeng Keosaeng is shown with US representative George Miller of the 7th Congressional District in the East Bay in Washington, DC, during the Immigrant Workers Freedom Ride March. (Courtesy of Khamsaeng Keosaeng.)

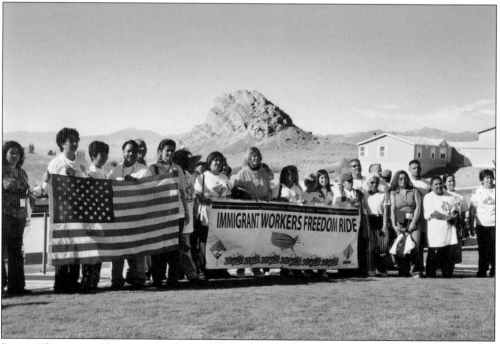

Pastor Khamsaeng Keosaeng holds the US flag with fellow immigrants in Utah on their way to Washington, DC, for the Immigrant Workers Freedom Ride March in 2003. (Courtesy of Khamsaeng Keosaeng.)

Laotian elders protest the Chevron expansion project at Kennedy High School in Richmond, California, in 2009. (Courtesy of the Asian Pacific Environmental Network.)

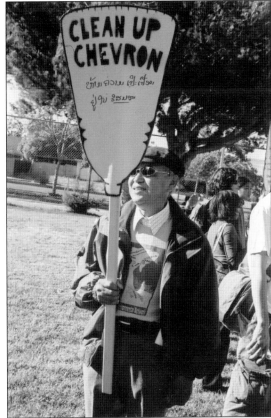

Torm Nompraseurt, Laotian project organizer, educates the Laotian community on the hazards of eating fish caught from the San Francisco Bay during a Seafood Consumption Campaign at Oakland's Chinatown Festival in 1996. (Courtesy of the Asian Pacific Environmental Network.)

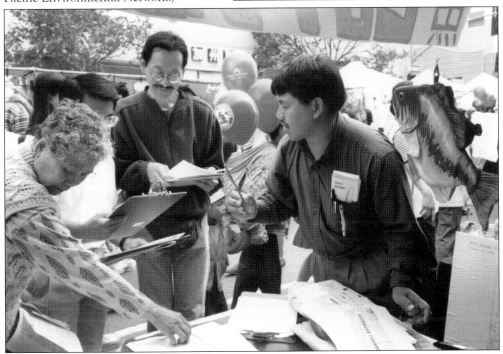

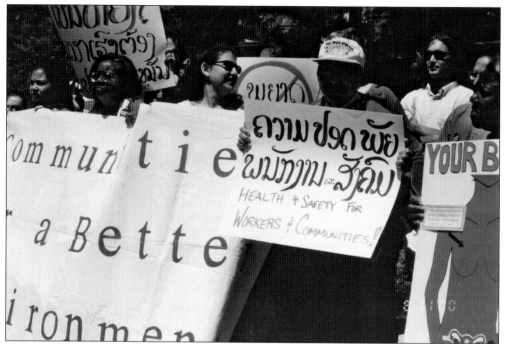

Khamphay Phahongchanh protests Chevron during a multilingual warning system campaign in Richmond, California, in 2000. (Courtesy of the Asian Pacific Environmental Network.)

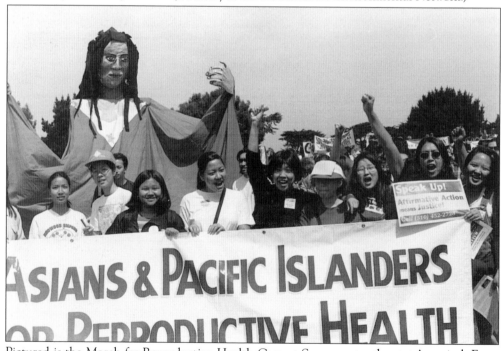

Pictured is the March for Reproductive Health Care at Sacramento, the state's capital. From left to right are Kelly Khamorn, Karen Chin, Fam Saechao, Sipfou Saechao, Peggy Saika, Maiko Thao, Lori Kodama, Cynthia Choi, and Sun Hyung Lee. (Courtesy of the Asian Pacific Environmental Network.)

Here, Chao K. Nokham receives the US Republican Senatorial Medal of Freedom in 2004. It is the highest and most prestigious honor Republican members of the US Senate can bestow on an individual. It is awarded by Sen. Mitch McConnell. (Courtesy of Chao K. Nokham.)

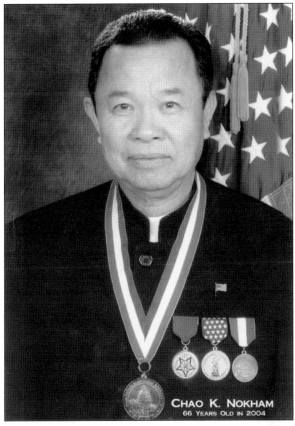

CHAO K. NOKHAM
66 YEARS OLD IN 2004

Lao dancers from Lao Seri Association perform at a fair in San Francisco's Tenderloin neighbor in 1988. (Courtesy of Bounchanh and Hongkkham Thepkaysone.)

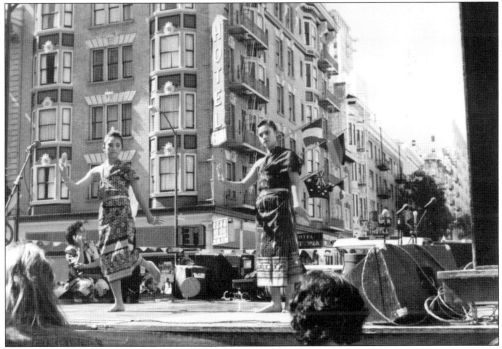

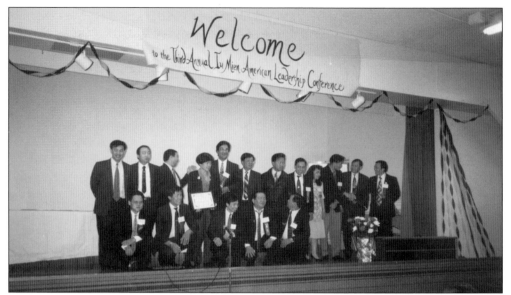

The 1994 Annual Iu Mien American Leadership Conference brought together Iu Mien community leaders, representatives, educators, business people, families, parents, and children to discuss community issues and exchange information. (Courtesy of Kouichoy Saechao.)

The Lao Oral History Archive (LOHA) documents the untold life stories of Lao refugees in the United States and comprises an online archive of interviews, videos, and historical documents. To date, the Center for Lao Studies has interviewed dozens of veterans from the San Francisco Bay Area and Minnesota and has collected over 200 hours of original video footage from ethnic Lao Loum, Tai Lue, Khmu, Iu Mien, and Hmongs. A preliminary website has been set up at www.laostudies.org/loha. Here is San Francisco's Asian Heritage Street Celebration in 2010. (Courtesy of the Center for Lao Studies.)

Boonthong Karnsouvong is an ethnic Khmu from Luang Prabang Province, Laos. In 1972, the Pathet Lao army attached his village. He escaped to a refugee camp in Thailand before coming to the United States in 1980. He is now 75 years old and resides in Richmond, California, with his family. (Courtesy of Todd Sanchioni.)

Thongsoun Phuthama is an ethnic Khmu who joined the Lao royal army when he was a teenager. With the help of his brother, Thongsoun escaped to Ban Thong Refugee Camp in Chiang Kong, Thailand, before coming to the United States in 1978 at the age of 60. He is now 87 years old and lives with his family in Richmond, California. (Courtesy of Todd Sanchioni.)

# Nine

# Businesses and Employment

Laotian refugee integration into American society economically was not smooth. Because a majority of Laotian refugees were from rural backgrounds and were illiterate and unskilled, the unemployment rate among the refugee population was high. As such, there was also a high percentage of Laotian refugees who were on the welfare roll. In addition, by the 1980s, Americans were, in large part, no longer sympathetic to the plight of the refugees from Southeast Asia, which has been described as "compassion fatigue." The first wave of refugees who arrived from April 1975 to 1976, right after the fall of Saigon, received considerably more resources and a more positive reception than those who arrived throughout the 1980s. The compassion fatigue syndrome was fueled by the economic recession of the early to mid-1980s, as well. Materially, this translated to fewer resources for resettlement and placement in poor communities and/or public housing projects. In the San Francisco Bay Area, this included public housing projects in Richmond, the Tenderloin, and West Oakland. The long-term effects of underfunding refugee resettlement resulted in Laotian Americans with low high school completion rates and even lower rates of college graduates. Therefore, they are less likely to possess steady employment. The Laotian-owned businesses in the San Francisco Bay Area reflect simultaneous social and economic conditions. Laotians who were unable to seek employment in the mainstream market created their own opportunities through entrepreneurship, and in creating a market that specializes in Laotian goods and services, a Laotian American community emerges. Today, Richmond and San Pablo are known as communities with Laotian-owned businesses. Many in the community want to create an economic center that will be known as "Lao Town."

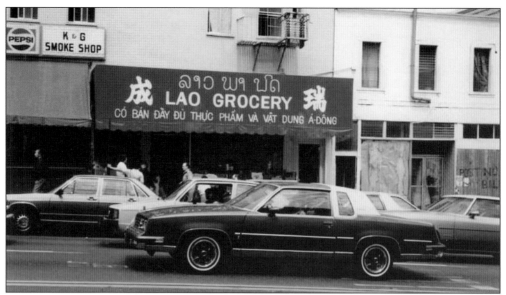

Lao Grocery Store is located near Stockton and Broadway in San Francisco's Chinatown in 1982. (Courtesy of Mitchell I. Bonner.)

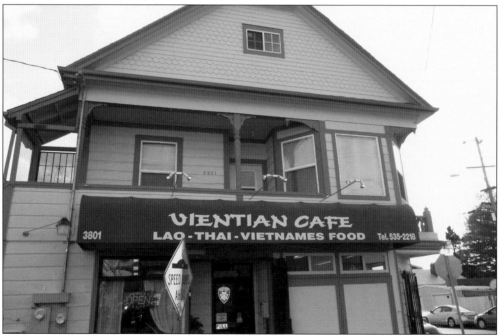

Opened in 2003 in an Oakland neighborhood by a Lao family, this restaurant first catered to the local Lao and Mien populations in the area. It is now popular among food enthusiasts outside the Lao refugee population and is slowly gaining a reputation as a trendy place to be. Typical Lao dishes such as *tam mak hung* (Lao papaya salad), *laab*, Lao sausage, and *som pa* (sour fermented fish) as well as noodle dishes are served here. The restaurant is named after the capital of Laos, Vientiane. However, there is an "e" missing at the end of the name. When the owners filed the paperwork, they dropped the "e" by accident. They did not want the hassle of filing more paperwork to change the name, so Vientian Café remains instead. (Courtesy of Vinya Sysamouth.)

Here is Chao K. Nokham Auto Sales Center in Oakland, California, in 1993. (Courtesy of Chao K. Nokham.)

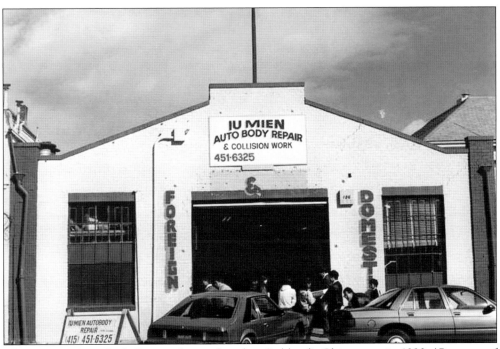

The Iu Mien Auto Body Repair shop is found in Oakland's Chinatown in 1990. (Courtesy of Mitchell I. Bonner.)

Sousiva Janetvilay (right) and coworker Peak ? work as prep ladies in the kitchen of a Thai restaurant in Berkeley, California, in 1987. (Courtesy of Boutsaba Janetvilay.)

Ray Soungpanya is at his first job at Catholic Charities in Alameda in 1981. (Courtesy of Ray Soungpanya.)

Wearing the polka-dot shirt, Ray Soungpanya (at far right) is at Alameda's Catholic Charities. He worked here for 15 years. This was his first full-time job after arriving in the United States. He assisted Catholic Charities with refugee resettlement. (Courtesy of Ray Soungpanya.)

Houmpheng Banouvong is at the Tuberculosis Control Section of San Francisco's General Hospital in 1994. He is interviewing a patient with tuberculosis exposure inside the tuberculosis clinic. (Courtesy of Houmpheng Banouvong.)

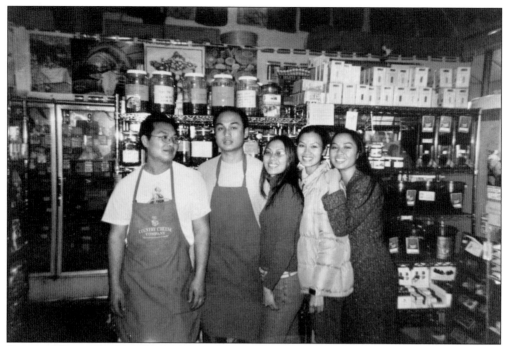

Country Cheese Company, located in Berkeley, California, is Laotian American family owned and operated. The Raxakoul family purchased the store in 1988. From left to right are Phouthaluck, Phithuck, Mairie, Mira, and Mola in 1991. (Courtesy of the Raxakoul family.)

Dr. Khammek Sackdavong is working at General Hospital. From 1982 to 2002, Dr. Sackdavong worked with the San Francisco Public Health Department Tuberculosis Control Division. Dr. Sackdavong is now retired and volunteers his time with the Lao Temple in Richmond, California. (Courtesy of Khammek Sackdavong.)

Samly Laundry and Dry Clean is located next door to the Mekong Market in San Pablo. Samly Sackdavong bought the laundry from the previous owner in 1995. The business catered to the refugees from Laos as well as Latino/a residents of San Pablo. (Courtesy of Khammany Mathavongsy.)

Its Lao customers know Kho's Auto Repair as Lao Chareurn. Located on Twenty-third Street in Richmond, the original auto repair shop was owned by an Iu Mien family since the mid-1980s. Kho, who is a Chinese Lao refugee, is the current owner and bought the business in early 2000s. The repair shop is conveniently located next door to his other business enterprise, Lao Chareurn Supermarket, or Hong Fath in Chinese, which has been in business since 1989. (Courtesy of Khammany Mathavongsy.)

Vientiane Hair Salon, located on Twenty-third Street and Dover Avenue in San Pablo, is the place to go for affordable haircuts for men, women, and children. Owned and operated since 1993 by Khamphone Khamsomphou, a Lao refugee, Vientiane Hair Salon caters to Lao, Thai, and Latino customers from west Contra Costa County. (Courtesy of Khammany Mathavongsy.)

That Luang Kitchen Lao Cuisine, formerly known as That Luang Market from 1990 to 2009, is among the new kids on the block specializing in Lao comfort food. The restaurant began in the kitchen of then–That Luang Market selling Lao favorites such as *tum mak hung* (Lao papaya salad), *laab*, and so on. Demand kept growing until the owners Leuan Sipaseuth and Loc Nguyen replaced the grocery with a full menu restaurant and nightclub on weekends. (Courtesy of Khammany Mathavongsy.)

# BIBLIOGRAPHY

Anderson, Wanni W. and Robert G. Lee, eds. "Between Necessity and Choice: Rhode Island Lao American Women." *Displacements and Diasporas: Asians in the Americas.* Piscataway, NJ: Rutgers State University Press, 2005.

Chan, Sucheng. *Hmong Means Free: Life in Laos and America.* Philadelphia: Temple University Press, 1994.

Chazée, Laurent. *The Peoples of Laos: Rural and Ethnic Diversities.* Bangkok: White Lotus Press, 1999.

Evans, Grant. *Laos: Culture and Society.* Seattle: University of Washington Press, 2000.

Fadiman, Anne. *The Spirit Catches You and You Fall Down: A Hmong Child, Her American Doctors, and the Collision of the Collision of Two Cultures.* New York: Farrar, Straus, and Giroux, 1997.

Hein, Jeremy. *Ethnic Origins: The Adaptation of Southeast Asian and Hmong Refugees in Four American Cities.* New York: Russell Sage Foundation, 2006.

Luangpraseut, Khamchong. *Laos Culturally Speaking.* San Diego: San Diego State University, Multifunctional Resource Center, 1987.

MacDonald, Jeffery. *Transnational Aspects of Iu-Mien Refugee Identity.* London: Routledge, 1997.

Qiu, Lian. "First International Lao New Year Festival." *AsianWeek*, April 3, 2009.

Ratnam, Perala. *Laos and Its Culture.* New Delhi: Tulsi Publishing House, 1982.

Taggart, Siegel. *Blue Collar and Buddha.* Evanston, IL: Siegel Productions, 1987. DVD.

Van Esterik, Penny. *Taking Refuge: Lao Buddhist in North America.* Monograph in Southeast Asian Studies. Tempe: Arizona State University, 1992.

# INDEX